Who's My Bottom?

Christopher Gillett

ISBN 978-1-4476-7493-1

To Lucy, Tessa and Adam

Flute's First Scene

(Britten's *A Midsummer Night's Dream*)

Flute, a bellows mender, and five other local craftsmen meet in the woods. These are the Rustics. Quince has devised a play for them to perform at the Duke's wedding party, *Pyramus and Thisbe,* and he hands out the roles. Bottom will play Pyramus (even though he'd like to play all of the roles) and Flute gets Thisbe, whom he imagines, given that it's a title role, to be a wandering knight. He's not happy when he discovers that Thisbe is a girl. It's only when Bottom announces that he wants to play Thisbe, and demonstrates how he'd do it, that Flute decides it can't be too bad. Flute quietly imitates Bottom's version of Thisbe and is alarmed to find his voice breaking on all the high notes. When Bottom nags Quince to let him play the Lion as well as Pyramus, Flute panics; he fears Bottom will be rather too good at it and they'll all be hanged. (Besides, why can't he just stick to Pyramus?) Quince hands out the scripts and tells them all to meet again in the woods later to rehearse.

say what the play treats on

Madrid.

In front of me is a cheery-looking, grey-haired and portly man. I extend my hand.

"Hi, I'm Chris. Flute."

"Conal. Bottom."

Unusual name. His accent is antipodean.

"Really? Flute? I was expecting someone young and cute!"

He grins and jabs his elbow at me.

This is the very first meeting of the cast of the Teatro Real's new production of *A Midsummer Night's Dream*, and while there are some familiar faces, most of the singers are new to me. We've gathered in a modern, airy studio - the chorus room by the look of it - and we're about to kick off with a music rehearsal.

In a very few hours we could be rolling around on the floor, naked for all I know - in the process of rehearsal I should add - so there's an understandable amount of mutual scrutiny going on. You could call this the Doggy Rehearsal; we've been taken to the park and we are madly and metaphorically sniffing each other's bottoms.

I've been given a good whiff of Bottom's bottom in one short introduction - he's clearly very good at this. Me, I'm not. I prefer to be rather more enigmatic. If need be I can whip out a lengthy anecdote which establishes me firmly and, I hope, a little dully as a Family Man, someone who's not interested in any high-jinks at or after work.

I circulate, introducing myself, embracing the ones I know and almost instantly forgetting the names of the ones I don't. Not out of any malice, I should add, but simply because I remember names about as well as a teenager remembers to switch off lights.

You might think that I would be fully aware of who my fellow cast members are going to be well before we start rehearsals but, curiously, I have yet to work at *any* opera house where they bother to tell you who you'll be working with before you actually start the job. Odd isn't it?

I arrived in Madrid two days ago. We were originally supposed to start rehearsing yesterday, on Sunday.

"Are you sure?" I asked my agent. "Sunday? Really? In Spain? Good Catholics and all that…"

"That's what they're saying. Sunday."

"Can you double-check that?"

He double-checks.

"Yup. Sunday. They're saying that's definitely when you start."

So I booked my non-changeable flight, paid the non-returnable deposit on my digs and almost as soon as I had done so my agent called to tell me that rehearsals would start a day later, on Monday.

There are worse places to waste a couple of days than Madrid but it still niggles a bit that they couldn't get their act together and consider that I might actually prefer to stay at home. So I fly in on the Saturday evening. It's early December. I've booked a very small apartment on the internet and I work my way there via the unfamiliar Metro and a long walk up the honking Calle Atocha, dragging my reluctant suitcase behind me. It's busy. The *Madrilenos* are window-shopping en masse, moving out of the way grumpily as I and my large suitcase roll towards them, the wheels clacking loudly on the distressed pavement.

I'm looking for Maestro Churrero, a *churros* shop on the Calle, not because I have an overwhelming urge for long, ridged donuts, (though that's not too far from my mind) but because that's where I have to collect the key for my apartment. From what I can garner from the internet, my apartment is right above the *churreria.* I have the prospect of several weeks of sinful, fatty and chocolatey aromas wafting upstairs. Actually it begins to sound like Nirvana. God bless Google for finding me this place.

The *churreria* is doing a roaring trade. In broken Spanish I ask for my contact, Senor Sixto. A waiter finds him at the till, I collect my keys and I move in.

The apartment is much as I expected: small, bleak and sparse. The floors are tiled throughout and there are no rugs. The solitary ceiling light is fluorescent and it hums prodigiously. There's a solitary armchair and two chairs at the clunky little pine table. The woodwork and curtains are the colour of raw liver. In the bedroom are two single beds that wouldn't be out of place in a dormitory, while on the wall there is a 14" TV on a bracket, much like you might see in a hospital, and a terrible painting of a wide-eyed peasant girl clutching a cockerel. The telly has no aerial cable, so there is no picture. This is my home for seven weeks. This is where I'll spend the run-up to Christmas and

where I'll see in the new year. But it's clean, warm and there's only the faintest waft of donut, so it will have to do.

Our rehearsal, scheduled as a sing-through of the entire opera, is taking its sweet time in starting. We're running out of chit-chat. All the bums are sniffed.

Someone from the administration appears and explains that the conductor is flying in from Japan and his flight is slightly delayed. "So, eef you pleeess, all come back again in three hours!"

My immediate thought is that, in these circumstances, I could have flown in this morning, had two more days at home and saved myself two days' rent on my liver-hued apartment.

My second thought is to reflect on how often this happens to me, and particularly in this role. Flute.

This is my fifth production of *A Midsummer Night's Dream* playing Flute, my seventh production of the opera when I include the two in which I've sung Lysander. Given the vast number of revivals I have done in addition to the new productions, I have spent much more than an entire year rehearsing this opera (and it is perhaps worth pointing out here that singers are not paid for rehearsals – not one penny). That's about two percent of my entire life and five percent of my working life so far. I've been singing him for 21 years. I last sang the role only eight months ago in Barcelona, after yet another month's rehearsal. I must be the only Flute in Spain, not least the oldest. How many other Flutes in the world have started having hair grow out of their ears?

And the more I think about it, the more I wonder if Flute and I aren't living in some sort of parallel universe. Why *am* I the only tenor, as far as I can tell, to have played Flute in Spain? In Italy too for that matter? Am I really good at playing Flute? Or is this simply how people see me now and they are just casting from type? He has been such a centrepiece of my career; have I actually *become* Flute?

What does Flute want? To be the star, the heroic lead - "a wandering knight". What does he get? To dress up as a girl and to be the object of mirth.

Come to think of it, it really doesn't sound so very different from what I've done all my working life.

what is Thisbe?

1984

I'm in a dressing-room at Covent Garden, I'm all of 25 and, as Flute, I'm about to make my Royal Opera debut.
Not bad Gillett. That's pretty respectable. This is something a lot of British jobbing singers never achieve. Ever. Most of those that do don't get here until they're in their 30s.
My very first day here the tenor who's singing Lysander said: "God you're young. I don't know, I'm not into all this encouraging young singers lark. As far as I'm concerned, you climb the ladder and push it away when you've got to the top." At least he was grinning when he said it.

So, alright, when you decided five years ago that you were going to try your hand at being a professional singer you set yourself a silly goal. You said that if you hadn't sung Peter Grimes at Covent Garden by the age of 30 you would give up and follow the path that had more obviously been laid out for you. Something in the City.
Who were you kidding? *Peter Grimes*??
That's because everybody used to say you had a well-developed voice. Could be true. Or it could have been that you were good at imitating older singers without really having a clue what you were doing.
Anyway, you're here now, so shut up and get on with it.
There's a telegram from Father/Daddy/Robin…. Oh I don't know what to call him anymore. Nothing at all if possible. Avoid it. "Daddy"? I don't think so. So how do I address him? Mumble something incomprehensible, that'll do.
The telegram says "You said you wanted to sing Peter Grimes at Covent Garden by 30. Flute seems pretty good to me. Well done and break a leg."
I should tell him that in opera no-one says "break a leg". Luvvies do that. We have "toi toi toi", pronounced "toy", something we have inherited from Germany where they say it as if spitting over your shoulder.
Never mind. Let it go. Let him say "break a leg".

I'm pulling on my costume. It's a good part, Flute, particularly for a debut. Peter Pears sang it at the premiere, not the larger role of Lysander. People forget that.

Lysander's the more serious role. It's the one they think of as the proper singer's role. The lyric tenor. But Flute is tricky. High. Needs to be sung properly. It's not as easy a role as it might sound. And you have Thisbe's "big" aria at the end, as near to a show-stopper as a comic role can have. By then, everyone's bored of the Lovers. It's become the Rustics' evening and that's not to be sniffed at.

Me, singing an aria at Covent Garden while the rest of the cast looks on. This is big, nerve-wracking stuff. The lights dimmed, a feint impression of the gold and plush of the Royal Opera House the other side of the pit. Follow spot. Laughter. A ripple of applause if you pull it off particularly well. A good roar for the Rustics as you take your curtain call - usually more than for the Lovers, which is always good for the ego.

No, it's a good role and who knows, if I play it properly, sing it well, hopefully the people at the top, the management, may think of me as a serious singer. I know that may be a bit of a leap for them but I'm not ready to be put in a pigeon-hole yet. Yes I can do funny but give me the chance and I'll show you I can do serious as well! Really, I can. So yes, enjoy me camping about, tripping over my dress and all that stuff, doing all the vocal cracks because Flute - yes *Flute* and not *Chris* - finds the role of Thisbe too high. But a bit of me would also like you to ignore all that and hear whether or not I'm *singing* it well. There are times when I want to step down to the footlights and say "You do know that all those bits when Flute squawks comically because he can't get the high notes are actually in the score? I'm doing what the composer wrote. I'm not squawking because I can't do it, I'm squawking because Britten said so. Good, as long as we're clear on that."

In the meantime though, I'll get on with it.

This is good stuff. I have absolutely nothing to complain about. Funny will do for the moment. Thank goodness for Luck. Or is it Synchronicity? I don't know. All I know is that John Copley saw me do a Nanki-Poo last year, and then he happened to do some workshops at the National Opera Studio. I did Basilio in *Figaro* with him. The Studio had originally planned *The Rake's Progress* but had a change of heart at the last minute, fortunately for me.

The fact I'd already done Basilio on stage several times gave me an edge that I wouldn't have had with the Stravinsky. John seemed to think I could do comedy. Next thing I knew was that the Royal Opera was summoning me for an audition. On the big day, as he shimmied across the stage to join the rest of the audition panel in the stalls Copley mouthed a "good luck!" at me which was very reassuring.

When I was offered the part, six shows at £145 per show, I wanted to yell it from the rooftops, but my agent said that for reasons I couldn't be privy to I had to keep quiet about it until further notice. So for months I had to keep my mouth shut about my big fat break.

I even got married. Well why not? I'd made it hadn't I?

Each day as I've putt-putted on my moped to rehearsals I've imagined that the ripples of this will spread far and wide. Now I will have sung at Covent Garden it can surely only be a matter of moments before opera houses around the globe will be knocking at my door. Well, you can dream.

Andy, an older bass who's playing Snug and also making his debut, is checking his make-up in the mirror. They've put the debutants (or in my case should that be debutante?) in the same dressing room.

"Of course," he says "making your debut here is the relatively easy bit. Getting asked back to do something else, now there's the real hurdle."

Oh, I hadn't thought of it that way. That's something I don't want to think about on-stage thank you.

We're called to the stage. There's much clearing of throats from the wings.

It's dead posh here. So far, in my limited stage experience at other theatres, I've had to listen for my own musical cue for my entrance and send myself on stage. Here they post a stage-manager next to us who tells us exactly when to enter. But he doesn't just point a finger and say "go". It being Covent Garden he says "Thank you, gentlemen, if you'd like to make your entrance now please....". And off we go, wending our way across the John Piper set. Surely my colleagues can hear my heart thumping with nerves.

You have to be careful. The set is basically a large mound made out of sacking, papier-mâché and what look like mop heads and which, on close inspection, are in fact mop heads. This production, originally by John Gielgud, is twenty-odd years old. Step in the wrong place and your foot will go straight through the set, and then no-one will be laughing.

a wandering knight?

Covent Garden does ask me back, first to understudy Hermes in *King Priam* and then to sing the role when the company does a short tour to Athens. This is more like it. International work. My fee has leapt too, by a whopping five quid per show. Sitting around the hotel pool with the rest of the company I smugly feel I'm where I belong. This is the life: five-star hotel paid for, per diem, Greece in July, a nice role, and all for The Royal Opera no less. Keep this up and I'll be singing the big roles soon, no problem.

For the next eight years I'm a regular face at the Garden. I even get a pass for the company car park. I almost never use it but it gives my third-hand Golf a certain *je ne sais quoi*. A lot of my work is understudying, which in opera can make you feel like the lowest form of life and more than a little lonely in the canteen. The singer I am understudying is usually wary of me because all he can see is me looking at him wishing he'd come down with some wildly disabling ailment, or so he imagines, and all the chorus tenors resent me because they can't see why they're being denied the opportunity to cover and earn valuable overtime by an inexperienced little runt like me.

The understudying is pretty easy - a few calls with a coach, then two weeks sitting in the stalls watching the production. Sometimes we get to rehearse the staging but it is pretty rare. Most of the time we hang around the canteen, read newspapers and chat.

I do some very small roles in very big operas. In *Parsifal* I am one of the four Esquires. We have a few solo lines near the start and a brief quartet after we've listened to Gurnemanz sing at us for what seems like half an hour, all in the first act. After that we're free to go. No curtain call for us.

One of the performances of *Parsifal* starts early, at four o'clock on a Saturday, and is being relayed live by Radio 3. After I'm done, I have to take a train to Manchester where I have a rehearsal the next morning for a concert I'm doing with the Hallé Orchestra in a couple of days. A fellow Esquire gives me lift to King's Cross where I catch a train. I absorb myself in the score of the concert I'm going to rehearse, Tippett's *The Mask of Time*, which I'm jumping in to do at a few days' notice. The train is full

of rugby supporters who are jovial but well-oiled. *Parsifal* is quickly a distant memory.

After a few hours we arrive at Manchester Piccadilly, it's a fine day and I amble to my hotel. I check in. I go up to my room and unpack. I fiddle with the radio controls, stumble on Radio 3 and the music playing sounds like Wagner. It's the *Parsifal* from Covent Garden, still going out live. There's another forty minutes of it left. When it gets to the end, the announcer reads out the cast and there's my name. Little does he or the listening public know that I'm already 200 miles away.

The bosses at the Garden take the plunge and offer me a big role, Dov, the gay musician in Tippett's *The Knot Garden.* Though perhaps not the butchest in the repertoire this is the lead tenor role. No more prancing around in a dress for me. Well, apart from a fair bit of the last act where I have to camp around playacting Ariel from *The Tempest.* I've sung Dov before in a student production and it suited me well in a small theatre. The opera house is a lot bigger but I feel pretty confident I can handle it. Nick Hytner is directing and we've known each other for years. He directed my first opera, at Cambridge, and we've done another five of the things together since. We're old mates.

Rehearsals in the studio go well. It's all looking very promising. Then we hit the stage and the problems start. Our Denise cancels. She's been having vocal problems and decides she can't sing it. Her understudy steps in.

Then there are huge technical problems with the relatively simple set and most of our rehearsals grind to a halt because something won't open or close or go up or go down. Nick Hytner spends large amounts of his precious few rehearsals going ballistic at the lack of technical competence and swearing he'll never work here again.

When the orchestra joins us we're overwhelmed by the unremitting volume it is pumping out. Even the bigger-voiced amongst us are struggling to be heard. Any subtlety of dynamics is flying out of the window. It's a case of yell or drown. It's hardly surprising when Tippett has scored an amplified electric guitar in the pit. It's as if all the guitarist's non-electric colleagues are thinking "oh well, if he's going to be playing *forte* all night then I may as well too...".

On the phone to my agent I ask her when she's coming to see the show. "Oh God, I'm not coming to that. I hate that bloody opera. Loathe it." She isn't my agent for very much longer.

The day before the dress rehearsal, my worst fear is realised. I'm getting a sore throat. I coast through our last rehearsal before I'm rushed off to see an expensive throat specialist who tells me I have an infection, a cold.

Oh great. The one thing I was dreading and it happens. I'm told to take the dress rehearsal off. My understudy, Paul, rings me in a panic and begs me not to cancel the first night. He's having kittens as it is about replacing me in the public Dress.

Alan, who's singing Mangus, also misses the dress because he needs a small but urgent operation on his leg.

I spend two days dosing myself with every conceivable potion. I have no voice at all, my only ray of hope being that it isn't on my larynx. I lie in bed vacillating between hoping I'll be better and thinking it would be much better if I simply cancelled. But this is my big moment. How can I possibly think of cancelling? If I've got any vim and vigour I'll overcome this obstacle and be a star! Besides I could do with the fee. It will help to pay the cost of the throat specialist. If I don't sing, I won't get a penny. After five weeks of unpaid rehearsals I'm feeling broke. I've got a mortgage to pay and a family to support.

So I turn up for the first night thick with snot. Nick Hytner has a little pow-wow with the cast before the show. Tonight will be the very first complete run we've managed on stage with the orchestra and the entire cast. He's putting a positive gloss on this unusual state of affairs but it is a pretty daunting prospect.

If only some national disaster like an earthquake or terrible holocaust could spare me from tonight. The whole show could be cancelled, nobody would know and I wouldn't have to go through all this.

I warm up as best I can but I'm only firing on two cylinders, if that. I go out there, paralysed with fear. I scrape through but it's really not good enough. I can see the concerned looks in my colleagues' eyes. I'm not doing myself a lot of favours by being on this stage in this opera tonight. At the end of my big aria, tough at the best of times, and positively excruciating in my condition, Linda, the Flora, asks me "how are you doing?" with an overwhelming look of pity. There's still another act to do.

Afterwards everyone is polite but restrained. When the reviews come out they're not good. Some turn a blind eye, one does say

how good the one quiet scene is "especially if you're sitting close to the stage", and one says I'm "pathetic". This doesn't bode well. The Garden isn't going to be falling over itself to have me back in big roles again after this. Illness is not easily forgiven. It shows a lack of judgment.

As it is I'm back into small parts again. Although this pays the bills and I am happy to be at Covent Garden at all, I have a feeling that the time is going to come when I'm going to have to move on elsewhere or I'll become so much a part of the furniture that I'll disappear altogether, and frankly it's a bit too soon in my career for that.

In *Turandot* I play Pang, which is quite a lot to do, and the Prince of Persia, which is not; just the singing of "TURANDOT!!!" from the wings near the beginning but which is more nerve-wracking than all the running around I have to do as Pang. The big parts are being taken by Gwyneth Jones, who seems okay albeit in a slightly grand way, and Franco Bonisolli who is a complete nutter. An ex ski-instructor with dyed jet black hair, he leaps around the stage as if he were on the Matterhorn. I've seen him in action before at a dress rehearsal of *Il Trovatore* when he reckoned the curtain was coming down too fast during his top C at the end of *Di Quella Pira,* so he tried in vain to hold it up with his sword. He doesn't so much move as strut.

At one point in the show, Ping, Pong and I have to prostrate ourselves while Gwyneth Jones sings her big number *In Questa Reggia* and she is so loud I'm convinced my ears are going to start bleeding. "Oh shut up please, God, oh ow, pleeeeease!" my head is saying while my body is the model of servitude. A little later in the show I have to gaze in admiration as she crosses in front of me, heading upstage. Every night without fail, she takes the opportunity to wipe her finger subtly under her lightly dripping nose. The audience has no idea as she has her back to them but for me it's a treasured moment, seeing a Dame of the realm wiping her nose without her hanky.

I play Pang again in a raft of performances in Wembley Arena where they're hoping to fill the 12,000 seats with people who want to hear *Nessun Dorma* sung live. Nearly every night the main roles are sung by a new cast of stars who do no rehearsal and are walked through the show beforehand by a director's assistant. It is a bizarre experience. Each night I hurtle a few

hundred yards onto the enormous stage to lay hands on a Calaf I've never seen before, not even backstage, and "act" with him. Sometimes he's surprisingly short, sometimes he's surprisingly portly. As he can barely remember the production, from lack of rehearsal, we have to do a lot of manhandling to get him to stand in the right place.

We're all wearing tiny head mikes with the battery packs and transceivers hidden in our costumes, usually in our belts, the arena is just so huge.

One night as I run out I'm thinking: *OK who do we have on the menu for Calaf tonight? And where is he? Oh there he is. Short-arse with platform shoes. Downstage centre. Natch. Ooh, packed house tonight. Alright then Giuseppe, or whatever your name is, cop a load of this…*

And, as per the production I grab hold of his arm and start imploring him menacingly to shut up and go home. The moment I grab his arm, Giuseppe, the tenor, leaps out of character and starts yelling at me "No no no! Attenzione!! Il microfono! Il microfono!!" and pawing at me to let go of him. *Hello, feisty one we've got here!* It suddenly dawns on me that he's in a very real panic.

What's this under my hand in his costume? Christ, it's his microphone pack. What's it doing there? Shouldn't it be in his waistband? Ah, look at the size of his waist. Nuff said.

I let go, and he, totally oblivious to any fear of dramatic incongruity, fiddles inside his sleeve and fusses with the battery pack until he is satisfied all is well. I sympathise, poor love. No point in going out there and singing your balls off if the technology is going to let you down. In this place you'd be as well off simply opening and closing your mouth in time to the music.

In a revival of an old *Samson et Dalila* I play a Philistine, which seems like a piece of natural casting. I have only three lines to sing but a fair amount of business bang centre downstage; a few ladies from the chorus get thrown at my feet, I grab their jewels, weigh the jewels in some scales and generally act the self-important Bad Guy in a long frock. For some reason, my face is painted gold.

José Carreras is singing his first Samson on stage, although he has recorded it. He's a friendly guy but it's clear during the very short rehearsal period that he's not yet totally at home in the role.

During the dress rehearsal he gets lost a few times and is not exuding the air of being a happy man.

Two days later, the First Night, Steven the revival director comes into my dressing room and says "Oh, I should let you know, José has insisted on a prompter so there'll be a prompt box for the first time, centre stage. All that business you have with grabbing the jewels off the chorus ladies, just move it a couple of yards to your right so as not to get in the way of the prompter."

Fine, I'm a pro, I can handle this, no problems.

The opera begins, I swagger on stage looking meaner than a bulldog licking pee off a nettle, or so I imagine, and assume my Philistine bully-cum-grabber-of-jewellery position two yards to the right of my usual spot. I've clocked the prompt box and it's a biggy. And there, inside this new monolith at the centre of the footlights is Alistair, score open, ready to prompt José when he starts singing in a few minutes.

Alright then, off we go. I signal to my fellow Philistine, in my very best Cecil B de Mille silent movie mime that I am ready for him to fling me my first victim.

There's Mildred, from the chorus, acting her socks off as she struggles with Philistine Two, and now here she comes hurtling towards me.

Hang on, she's going rather fast considering I'm much closer than when we last did this. Uh oh.

And, apparently unprepared for the fact that I am now two yards nearer than before, Mildred, rather than landing at my feet, catapults straight into the sides of my knees, sending me over like a well-hit tenpin. I'm on the floor, my frock up to my thighs, revealing very un-golden legs, my knickers probably on display, my scales almost in the prompt box. It's a mess.

Israelites 1 Philistines 0

"Oops, sorry love", whispers Mildred. I scramble to my feet, noticing the odd chorus member quietly piss themselves, adjust my skirts and make extra-menacing gestures at Mildred. That's the trouble with opera. You can't simply bung in an improvised line like "How dare you, you Israelite harlot! You will hang for this!" The music chugs on and I have to do the best I can with some appalling mime. There's no disguising the cock-up though and I feel nicely humiliated, which is not the way round it's really supposed to be in the dramatic scheme of things.

I gather myself together. Now I have a bit of business when I have to ferry plates of confiscated jewellery several times in a

diagonal across the stage, from downstage left to upstage right in theatrical parlance. This while Samson launches into his first big moment.

I go about my routine of conveying the jewellery and on my second return back across the stage I can see José upstage of me, on a raised level, with a look of absolute and utter panic on his face.

Hello. What's up? Something wrong? His music's coming up isn't it?

And I realise his problem is me.

I'm walking back and forth right in front of the prompt box. The only thing between the prompter and José is me, Philistine One. There's probably been a conversation before the show with Alistair the prompter that has gone along the lines of : "Alistair, I am very, very worried about that first entrance."

"Never mind José, I'll be right there for you. Just look straight at me and I'll steer you in, no problem."

And then all José can see is some gold-faced idiot with a plate of jewellery, a crumpled costume and a slight limp, strutting around right in front of the damn prompt box as if he owned the bloody place.

I pick up his vibes, as they might say in California, and scurry out of the way in the nick of time. Only problem is, I've got a few more jewellery gathering journeys to make back downstage left. How on earth am I going to do them without blocking José's view of Alistair?

I do the best I can, and the audience is treated to the sight of Philistine One breaking into a little trot every time he comes anywhere remotely near the centre of the stage, and breaking out of it again and then walking absurdly slowly, as if he's momentarily forgotten an urgent plate of jewellery only to remember a couple of seconds later that it can wait a little while after all.

By the time I'm finished for the evening, which is about five minutes later (it's an early bath for the Philistines), I'm exhausted. There are two unwritten rules of small part singing: one, *don't fall over* and two, *don't mess things up for the big boys*, and I've just broken them both.

After various other bits and bobs my last outing at the Garden is as Moser, one of the *Meistersingers*. In our first scene, a large and tricky ensemble of a dozen Meisters, my large beard comes unglued and dangles from my left sideboard. I'm not sure how

bad it has looked until we come off stage and one of the basses hisses to me: "Well that scene hung together just about as well as your beard."

Perhaps it really is time to move on.

let not me play a woman, I have a beard coming

A pub, South Kensington, London. 1980

"Pint?"

"A bit early for me but yes, go on, why not?"

Bob Tear, my singing teacher at the Royal College of Music, is getting them in. It's not even midday but we've just finished a long lesson and neither of us has much on for the rest of the day. Bob is a star and I'm lucky he can squeeze any lessons at all into his busy schedule. I'm in awe of him, there's no doubt about that, and relax as much as I try I find it hard to feel totally at ease in his company. That's not his fault; he's totally affable and un-grand. I'm just star-struck and I can't seem to do anything about it. Perhaps a beer will help.

It's not hard to find a table in the empty pub and we sit down. We chat about various things we've been doing, his being significantly more impressive than mine. I've been listening to a lot of Wagner recently and I ask him if he would like to sing a certain role.

Bob says: "You know I never think like that. Let me give you some useful advice. Be ambitious, yes, but try not to have specific ambitions. The chances are you'll only be disappointed. Another pint?"

It's the best thing he ever teaches me.

(Bob's also famous for a conversation with a singer who told him that his ambition was to be "the best bass in the world". "That's lovely," Bob replied, "but how will you know?")

At the end of the year Bob has to write a report for me. "Chris will be a very useful member of the singing profession" is what he writes. I'm disappointed, almost devastated by the understatement. I hoped for something more glowing, more prophetic of a glorious career ahead.

It takes me twenty years to realise that it was the wisest possible thing to say; something which might be worthy even of a smidgen of pride.

If Flute's ambition is fuelled by ignorance then so is mine. But it's also fuelled by being given enormous things to do at a very young age. Three years being a big fish in the small sea of Cambridge University will do that to you. I have no idea exactly

what it is I want to do. Like so many of my age all I want is fame and fortune without any sense of a plan for achieving it, let alone questioning whether I actually have the ability. I almost think ambition itself is enough.

My first operatic role ever is Nero in Monteverdi's *The Coronation of Poppea,* at the age of nineteen, directed by Nicholas Hytner no less, who is three or so years older than me and on the bottom rung of his formidable career ladder. It is clear even in 1978 that he is destined for big things. In his turn, he thinks I could go far but, more particularly, that I should have sex with the professional mezzo-soprano he's got in to sing Ottavia. "It will be good for you" he smirks. Though the Ottavia is clearly up for it, I don't take his advice, being smitten with an unrequited crush on the Girton College organ-scholar.

I'll admit that nearly thirty years later the question still haunts me as to what mystical revelation might have occurred had I followed Nick's advice.

With the fearlessness of youth, by the time I am 23 I have sung Verdi's *Stiffelio* (yes, the title role) and Bacchus in *Ariadne auf Naxos.* (These are roles I'd never be asked to sing now but at the time I get rave reviews, something I still find hard to figure out. I'm not sure if this means I was being judged on my potential or whether the critics were talking absolute nonsense.) I actually believe I can sing just about anything, from Dowland to Wagner. I even appear on telly, in a close-harmony group cobbled together for Harold Wilson's short-lived chat show, singing *Raindrops Keep Falling On My Head.* I just don't know any better.

I am summoned to Covent Garden after my *Stiffelio* reviews. My agent - I even have one of those - suggests I sing something in French as they are interested in me for a small role in *L'Africaine.* I bring along a score of *Carmen* and sing the Flower Song, not from memory but clutching the music in my recently pubescent hands. They are not impressed, particularly as it turns out that they weren't interested in anything French but hoped to hear something from *Stiffelio.* At least I can blame my agent for that little cock-up.

I am too buried in my arrogant sense of destiny to take much heed to advice or warnings. Or to spend any time really learning anything about singing. I just seem to find a way to do that, a natural gift of mimicry rather than a true technique.

Still I'm not going to let something as dull as singing technique get in my way.

Another of my early roles, also directed by Nick Hytner, god bless him, is the Madwoman in Britten's *Curlew River*. It's a peach of a role and my first brush with professional transvestism. It's an all-male cast so there's no-one Nick can suggest that I screw in order to do me good, given that my proclivities aren't inclined that way.

After I've sung it a few times at various festivals I happen to be at an official lunch with Peter Pears and a dozen or so others. During a lull in the conversation someone says: "Sir Peter, Chris here has sung the Madwoman many times."

"Oh really? One of my favourite roles."

"Mmm, mine too" I say, blushing and my mouth full of quiche.

Now what am I supposed to say?

"The only trouble is, you have to spend so much time on your knees!" I quip feebly, pastry flying from my mouth like shrapnel.

Pears says nothing but looks at me as if I've just defaced *The Last Supper* with felt-tip. He never speaks to me again.

I'm asked to do *The Coronation of Poppea* again, this time by Kent Opera, only not the part of Nero but Arnalta, Poppea's nurse. It seems to go down rather well. I'm getting good at this character stuff. Besides, I think, if I do it well it only stands to reason that they'll think of me for bigger roles.

A few years later there's another *Poppea* in Amsterdam. Ottavia's nurse this time.

On the strength of that the conductor asks me to sing Hecuba in Cavalli's version of the Dido and Aeneas story, *La Didone*, in Lausanne and Montpellier. By now I'm getting an old hand at this travesty lark and I really am giving it all I've got, but a bit of me is still hankering to be the male lead rather than his mum.

In the Cavalli I do get to sing a male god, Mercury, but I have to clamber all over an enormous prostrate rhinoceros (I suppose this is quite usual in god circles) while wearing an overcoat that looks as if it was designed to fit King Kong and which must weigh 15 kilos, all the while singing an aria so stratospheric that it threatens to undermine the fertility of my testicles and leave them in vicinity of my neck. When the petite French conductor whines that my singing should sound calmer I can't help

wondering how calm he would sound tinkling his precious harpsichord if I were to stick a giant rhinoceros up his bum.

I'm asked to sing Leukipus in Richard Strauss's *Daphne* at Garsington. Here we go. My chance to get back on the lyric tenor rails again and prove I can do more than make people giggle with a skirt. It's a good sing - a part made famous by the great Fritz Wunderlich - but what I don't realise until I set about learning it is that I have to don a dress and disguise myself as a woman. That's probably why they cast me, because they knew I could.

And there are countless more Flutes, but more of him anon.

and you should do it too terribly

Driving through a leafy suburb one day in the late 80s I hear on Radio 3 a few minutes of a piece by Philip Glass, his opera *Satyagraha*. I only hear a few minutes because I find the music so utterly annoying that I switch over to Radio 4. Not my stuff at all. Even *Quote Unquote* is preferable to this agony. I've never heard any Glass before and I hope I'll never hear any more, ever again.

So it's no big surprise that I soon get a call asking if I'd be interested in being in Glass's newest opera which has the unbelievably cumbersome title: *The Making of the Representative for Planet 8.* I'm all enthusiasm and jolly-hockey-sticks keen-ness. "Yes, I'd love to do it."

The opera is based on a novel by Doris Lessing, who has been roped in to help with the libretto. It will be at English National Opera where I've not yet managed to sing and there'll be a further six performances in Amsterdam. To date my work abroad has been limited to the odd concert. It's about time I started being international and earning some serious foreign fees so I'm suddenly minimalist music's greatest fan.

This is not a straight-out offer. I should make that clear. ENO hasn't said to its collective self: "We're doing this new thing by Glass and Gillett's the only man for the job." Fat chance. There is an audition involved - when isn't there an audition involved? - but that proves to be, unusually, a piece of cake. My stock is quite high at the moment what with some reasonable roles at Covent Garden coming up, so a small but significant role in a new opera at ENO is not too hard to net.

I am to play Nooni, a bit of a goody-goody decent chap. Wading through the large score I discover that there's precious little to do in the first couple of acts bar act enthusiastically. All I've really got is a short and strangely trite aria in Act 3. Oh well, never mind. A job's a job.

The strange thing about the score is that there are acres and acres of music when no-one sings anything. The orchestra rambles on and on playing the same sequence of chords over and over again and then, suddenly, the plot will shoot forward in a frenzy followed by another expanse of repetitive twiddling from the pit with no apparent dramatic function. Large chunks of it aren't sung at all but are spoken, as if to cut a swathe through the libretto and make some dramatic progress. The whole opera

ends with a huge speech that if set to music it would last about an hour. If the whole libretto were sung in the way Glass has set the bits that are sung, the opera would have to last at least six hours to accommodate all the text. I've never encountered anything like it and my hunch is strong that it's really not very good.

My big moment comes at the start of Act 3 where I lead the search for a blue flower that will bring some relief to the people of our dying planet which is in the throes of an ice age. But then, wouldn't you just know it, I'm such a heroic idiot that I go a tad too far trying to pluck a blue flower, slip on an icy mountainside and plunge to my death. For the next twenty minutes I have to lie dead in a sledge, which is actually harder than you might think. Take it from me, playing dead for a long time is massively underrated as an acting skill.

The opera has already had its world premiere in Houston and ENO is hosting the production's second outing. But it wasn't an altogether rousing success in the States and the Japanese director has been sacked, leaving his assistant Harry to redo the production with the existing designs. This doesn't bode well. It smacks of desperation. We're left with the carcass of the concept and have to zap some life back into it. Already I'm thinking that this thing needs a dramatic defibrillator of massive proportions.

The first day of rehearsals and Glass and Lessing are there. In fact Doris dutifully rolls up for lots of rehearsals but has an uncomfortable air about her, as if she doesn't really know why she is here at all, beyond what she recognises as her usefulness to the PR department.

Rehearsals last a staggering eight weeks. Our director, Harry, thinks it would be useful in the creation of our Eden-esque planetary community if we learned Tai Chi, so every morning starts with half an hour of class. I enjoy it enormously but some of the older school of singer have a problem taking it too seriously.

Lesley Garrett is playing the female lead Alsi and we decide pretty early on that Alsi and Nooni, my part, should be lovers and that the best way to convey this is simply to snog a lot. So almost as soon as Act 1 begins we're downstage exchanging tongue-sandwiches to make the point. It's a lot of fun and it gives me something to do beside miming being the town hunk, a task not

made any easier by the costumes. Everyone on the planet is androgynous to the extent that they all wear the same clothes, male or female. Same hair even; a long black pony tail with chopsticks running through the tail, which must just confuse things even more for an audience. It's certainly pretty unnerving on stage.

The designer's big coup-de-theatre is a spaceship which brings the representative from Planet 8 to warn us of our impending doom. It looks ridiculous. It's an enormous version of a child's robot toy which descends from the flies amidst an absurd whoosh of dry ice. The design could have been nicked from Mattel.

My part, Nooni, was originally called Nonni in Doris's novel but they decided to change the name when reading the scene in which I fall to my death. As I climb the perilous rock Alsi is supposed to shout "Be careful! Nonni, Nonni! No!!!" which would, of course, raise a healthy chuckle were it in an Alan Ayckbourn but won't do in Glass's grand opera, so rather than change the line they change the name.

You have to throw yourself into a new opera, no matter what you think of the material, and *Planet 8* is no exception. I yield to the music's determined repetition and make myself believe in it. I practise my Tai Chi alone. I move around the stage in a zen-like state, propelled by the bubbling streams of arpeggios from the orchestra. I give it my best shot. We all do. I snog Lesley as if my life depended on it.

After the opening the head of ENO is reputedly so appalled by what he has witnessed, and for which he is ultimately responsible, that he writes a letter of resignation. The reviews are terrible. So much for my Coliseum debut. It will take a while to recover from this turkey.

There is a moment in the opera where our community has to build a wall to defend us from the ice flow. My job is to wander amongst the chorus egging them on to the task while the strings of the orchestra meander around a couple of chords for several minutes. All that is left is the final gap that has to be filled to give us a few more days' sanctuary against the ice and I traverse the stage quietly conveying the message that we must fill the gap. During the fourth performance, as I earnestly press the arms of

various chorus members I can hear one of the older tenors from the chorus as he struts, very un-Tai Chi-ly I should add, around the back of the stage, barking in a tone all too familiar from various London Underground stations: "MIND THE GAP! MIND THE GAP!"

every mother's son

"Netherlands Opera has asked you to do *Eugene Onegin.*" says my agent.

"What? Lensky?" I ask, my voice dosed with a cocktail of disbelief and over-optimism.

"Er, no, Monsieur Triquet."

"Aren't I a bit young for that? I thought it was an old man's role."

"Yes, ordinarily, but they've got a director who wants a younger model, so they say. I think you should do it." (Meaning: *I won't have to find you anything else in those two months, there are lots of performances and I'll do nicely for commission.*)

So I say yes. A bit of "normal" opera wouldn't go amiss. Besides Triquet has just one scene and a lovely little aria. It's what you might call a cameo role as opposed to a small role.

Two years later, it's my first rehearsal for *Onegin* and I've turned up looking as youthful as I can for my 38 years. Johannes Schaff is directing. When I'm introduced he looks at me like a child who, promised a pony for Christmas, has unwrapped a pair of socks. We start work on the scene.

"Zo," says Schaff, "ze main zing about Triquet is his age. You must zink of him as being.... ninety."

Wha...? But I thought you wanted a young guy?

"Zo, ve must give you a stick, and you must walk like zis..." and he demonstrates. Central Casting Doddery Old Git.

After the end of the rehearsal I'm depressed and on the phone to my agent to say there must be a mistake. Surely I've been horribly mis-cast.

"Oh yeah, didn't I tell you? The original director pulled out a few months ago so they got Schaff instead."

As the weeks go by I slowly start to develop something Schaff likes and I enjoy myself. Every time we do the scene he adds more business, more props, new gags with the onstage band, as if he's challenging me to screw it all up. It's as if he's hoping I'll fail so that he can have me fired and replaced with a real nonagenarian. For me the game becomes about proving I can handle anything he chucks at me. Some spectacular make-up, including a prosthetic nose and brow, and I really could pass for an old man. The show opens and I feel really comfortable with my little moment in the sun. Schaff finally concedes that he is happy with my Triquet. It's May, Amsterdam is looking beautiful,

I'm staying in a lovely apartment overlooking a canal. This is money for old rope.

In Cowes on the Isle of Wight a seventy year-old lady is in a supermarket buying a bottle of scotch. She is already drunk, in an alcoholic's joyless drunkenness, which doesn't go unnoticed by the staff. But she looks well-to-do in her yachty outfit and besides, this is Cowes; half the people who go in the supermarket are of the slightly-pissed yachty fraternity.
She walks back to the marina, a bit unsteady on her feet. She isn't usually this drunk but her husband is up in London for a couple of days and while he's away she can at least enjoy the luxury of drinking copiously and not in secret. Normally she has to use cola to disguise her vodka, sneaked from a bottle hidden behind her bunk, but on her own she can work her way through her drink of preference, whisky.
There's a stiff breeze blowing as she wobbles her way along the marina, past the rows of expensive yachts, to where the boat, her husband's pride and joy, is moored. The narrow pontoon is never stable underfoot at the best of times and the wind is pushing the boat away from its moorings. The old lady stretches to reach for the boat's handrail to pull the boat closer, but today, with the wind and the drink, it seems far beyond her reach.

A few hours later the little old lady is spotted by the crew of a yacht. She is floating, dead, in the River Medina.

The morning of my fourth *Onegin* performance my ex-wife calls me in Amsterdam.
"I just wanted to tell you how sorry I am about your mum."
"Why? What's happened?"
"Oh God, you haven't heard." And she explains. My mother has died. My father has called my ex because he can't find my number. He's in Cowes now. I ring him and he's trying to be calm and dignified, dignity as much his addiction as alcohol was my mother's, but he's confused and upset. He doesn't know how to get hold of my brother who's somewhere in the States. My wife Lucy is in the USA too, in New York. I tell him I'll find a way of finding my brother and letting him know.
And I have a performance tonight.
I don't know what to do. I'm upset and numb, full of a sort of nervous energy which I don't know how to expend. I should be

sorting something out, fixing something, but there's only one big thing right now in my life and I can't fix that.

I'm shocked at my mother's death but I'm not surprised she's gone. Alcohol had corroded our relationship almost as much as it had damaged her life. Still, as I walk the streets of Amsterdam I keep thinking I see her in every crowd.

The show must go on!

It's not a sentiment I easily understand. Of course if I had an understudy I would be well within my rights to pull out of tonight's performance, but I don't have one. Netherlands Opera doesn't employ them. So if I ring the theatre and say I can't do the show, they'll either have to try and fly someone in who knows the role and let him bodge his way through the production, or they'll have to cancel the whole thing.

So, I ring the theatre and let them know the situation. Hans, the company manager, is deeply sympathetic and I tell him not to worry, I'll do the show.

I spend the day tracking down my brother, on the phone, in a daze.

I go to the theatre, first for my one hour transformation into Triquet, then into my costume and onto the stage. I feel completely disconnected from the whole experience as if in a trance. My body does all that's required of it but that bit of me that has failed all day to break down and sob in private is threatening to reveal himself in this most public of places. I get through it but I've no idea how I would have coped had I been on stage for more than my allotted ten minutes.

Flute's Second Scene

The Rustics meet in the woods to rehearse the play. Bottom expresses reservations about the plot, and Flute joins in (possibly hoping that they can scupper this play and do another in which he won't have to play a girl). All the problems are solved and they start the rehearsal proper. Bottom delivers his fist lines as Pyramus then exits. Flute nervously delivers all his Thisbe lines at once, "cues and all". Bottom re-enters having been unwittingly transformed by Puck into an ass. The Rustics flee in panic.

for our rehearsal

Amsterdam

I am rehearsing a new opera, called simply *TEA*, which has been newly commissioned to celebrate the fifteenth anniversary of a concert hall in Tokyo, the Suntory Hall, built by the Japanese whisky-makers. The composer (and conductor) is Tan Dun, a Chinese-American who won an Oscar for his score of *Crouching Tiger, Hidden Dragon*. I don't know him but I know the director, Pierre Audi, who is also head of the Netherlands Opera where *TEA* will have some performances next year.

I was making a television film last year with Pierre and while we sat around at lunch he said "Chris, I'm doing a new opera by Tan Dooon next autumn and I think there's the perfect role for you - the angry brother. We'll be doing it in Tokyo, Amsterdam and probably China too. Are you interested? Shall I see what I can do?"

Tan Dooon? Who the hell's Tan Dooon? Pierre's pronunciation is often idiosyncratic.

"Oh, great, yes, I'd love to. Er, the only thing is I'm pencilled to do a *Cosi* in Liege so I'm not sure I can but, er, yes, great. Let me have a look. Let me talk to my agent." Always a good line that as it gives you some breathing space. Too much as it turns out.

A few months later my agent reveals that Liege has "gone in another direction" with their *Cosi*, which strikes me as a bit rich given that they'd already had me pencilled for a year or so. Not much I can do though so I turn my attention back to the Tan Dun, on which subject things have also gone a little bit quiet for my liking.

A quick conversation with Pierre along the lines of "Um, Pierre, you know that Tan Dun, er I mean Tan Dooon piece? How's that coming along?" reveals that I am up against another tenor whom Tan Dun has auditioned in New York.

My rival is offered the role. I'm a bit pissed off by this, having had no chance to audition myself. Now things aren't looking too rosy for next autumn. The *Cosi* has gone and my fall-back has gone too. It's getting a bit late in the day to expect something good to turn up in their place. I blame myself. I've been on a roll, with one job after another - opera, concerts, telly, more opera - and have glibly assumed that I can give up tending the future. Don't worry about it; it will just carry on as this year has been.

What!? Am I mad? I can't afford to be so off-hand. I'm now facing the prospect of scrubbing around for any work I can find to fill what looks to be a horrendous hole in my dairy. Golden rule: never assume you're on a roll. Always assume that unless you make things happen, nothing will happen at all. Why haven't I learned this yet?

Pierre is a bit contrite: "I'm sorry Chris but there's nothing I can do. It is Tan Doon's opera after all! You see? I can only give him suggestions but the man has his own ideas."

July 2002. Still no work in my diary for the autumn bar a couple of nice *War Requiems* and a *Messiah*.

My agent rings. "You're not going to believe this...."

Lo and behold, the other tenor hasn't signed his contract and has pulled out two months before rehearsals are due to start. Naughty boy. Ironically, he's been offered a nice *Cosi,* but not in Liege I hasten to add.

I'm back in the frame. Phew.

However the role hasn't been handed to me on a plate. Oh no. Much umming and aahing goes on as the buck is passed from one person to another, while no-one from management can make up their mind whether or not I'm really suitable. The problem for Audi isn't my acting – the character is a jealous, angry bugger and I seem to have played that sort of role a few times for him. No, the sticking point, it turns out, is a top C.

Now, let me tell you something about top Cs. The big myth is that all tenors really ought to have one. Well I can tell you straight away that there are an awful lot of the most famous tenors of the last century that didn't and still don't have one. As for myself I've sung a few, but not, to be honest, of the climactic, spine-tingling, get-a-load-of-this, fuck-off variety. My happier "money notes" are a tone or so below.

Another thing I can tell you is that 99.9% of any audience wouldn't have a clue as to whether you have sung a top C or a top A, a minor third lower. Now that's not very far really, a couple of notes. But I can also tell you that short distance, less than two inches on a piano keyboard, in tenor terms is like the difference between hiking up Snowdon and climbing Mount Everest. Saying you have a top C when you really only have an A is like claiming to own a Ferrari when there's a Morris Minor hiding in the garage. If you take the silencer off the Morris and rev it up

without letting anyone see what's behind the garage door, you can fool a lot of people a lot of the time into believing that you really drive something rather more exotic. And that's what a lot of rather well-known singers do.

So what makes a good high note? What an audience hears is a mixture of effort, resonance ("ping", if you like) and sheer balls. If the audience hears the climactic high note sung in a certain way, it is happy. Too easy and it hasn't had its money's worth. Too hard and it is put off by the strain. For the tenor it's a nightmare. There is nothing worse I can think of than singing a top C, then having someone unfamiliar with the score say: "Was it really? Didn't sound like it. Sounded more like a Bb. In the middle of your voice, mate."

I mean, what's the point?

Unfortunately no-one seems to have told composers about this, so the more naïve of them chuck them in willy-nilly thinking that doing so will increase the thrill factor, without realising that the same effect could be achieved without the tenor shitting himself all day about whether or not he'll make it over the high jump that night.

Of course many top Cs have now entered the repertoire as *de rigeur* and opera fans eagerly await them to see whether or not the tenor will fail in his ordeal. (Hardcore opera fans tend to be oddballs, people who delight as much in seeing something go hideously wrong as well as wonderfully right. Think of opera as bullfighting and you get the picture.) The irony is that in many cases - and I have to say I find this rather funny - the know-it-alls aren't actually getting their prescribed diet of high notes. Rodolfo's aria "Che Gelida Manina" in *La Boheme* has perhaps the most famous of all top Cs. But I've heard the opera several times at Covent Garden with that aria transposed down a whole tone. Did I ask for my money back? No. Did any of the audience hear the transposition? Not many. So even the most famous of Cs cannot be taken as vital in their own right.

So the question is put to me for the Tan Dun role: "have you got the top C?"

I reply: "If you want a huge Italianate ringing thing that peels paint then frankly no. Have I got the note, yes."

And so, because they're so near the bottom of the barrel, thank god, I get the part, and spend the next weeks practising; banging

away at my top register every day, enough to drive the neighbours' pets to distraction, if only they had any.

In *TEA* the biggest top C is sandwiched directly between two top Bs in the last act. Pierre Audi has been going on about it on the phone. It will be my very last line in the opera.
"Can you sing it Chris? It is a very climactic moment!"
It's a tough phrase for sure that makes the C in *La Boheme* seem a positive doddle, and in practising it I haven't always nailed it as well as I would like. Some days it is, though I say it myself, something of a stonker. And other days it sounds like a liquidiser mangling ice cubes. It's a phrase from heaven or from hell, but from nowhere in between. I make a point of singing it every day but choosing my moment to present it in all its glory to The Management for the first time will be tricky. I don't want to attempt it at the end of a long and tiring rehearsal or it will be a liquidiser moment. No, I want to show it off when the circumstances are right. If I screw it up, it will not only worry them, more importantly it will worry me. Singing it at a morning rehearsal would probably be a mistake as the voice, in spite of a good warm up, is never as flexible and clear too early in the day. Nope, that C is going to be a source of anxiety for a while; a bull-terrier nipping at my heels by day and, as a friend of mine eloquently put it, rogering my leg well into the night as well.
The role learned, I fly to Amsterdam to rehearse.

One thing should be said about opera productions. By the time the singers turn up for rehearsals the success or failure of the whole venture is pretty-well determined. We, the lowly singers, have no idea what the design concept will be, least of all have any say in it. So the director's introduction is almost the most critical moment in the whole process. It's the occasion where you have to wear your bravest smiles. Imagine what it must be like if all your working life you have dreamed to play, say, Don Giovanni. (Yes I know it's not a tenor role, but stick with me, just for the sake of an example.) You know that the eyes of the opera world will be upon you to see how you do. If this is a success, you think, it could be a real door-opener. You prepare. You start to have a few ideas how scenes might go. You allow your imagination to potter around the corridors of your ambition. And then you get to the director's introduction and he says he wants to explore a Jungian analysis of a recent boyfriend's recurrent

dream, so he's decided to set the production in a Colombian drugs-baron's jungle hideout with Don Giovanni wearing full Samurai armour made out of pink rubber..... At that precise moment you realise that your career is going to take a knock, because no matter what you do in the next four weeks of rehearsal, you're pretty-well doomed.

This production will not be so extreme, but in spite of the fact that the composer (who as I've already mentioned is also the conductor) has very specifically located his opera in China and Japan the production team has decided it would be pure folly to follow this basic and obvious concept. The argument is that we are not Orientals (though in fact two of the cast of five are) so it would be foolish to pretend. Fair enough, but I'm already worrying that Tan Dun will start to resent the fact that his imagination has been so casually dismissed.

We are shown costume designs which are, in fact, bunches of seemingly random geometric shapes in various colours with suggestions of hands and heads in approximately the right places. I have come to expect this. I've worked with this designer before in a show where I had to wear what amounted to a large marshmallow made out of duvet fabric and ridiculously long pointy shoes. At least my greatest fear, a hat, is nowhere to be seen. I hate singing in hats.

The introduction is all but over – the composer has had his say as well as the director – and we are just shifting our collective weight in our seats with a coffee break in mind when someone else who bears all the hallmarks of an ex-hippie decides he'd like to say something. It turns out to be the Dutchman who will be filming video material that will make up part of the décor.

"Hi. I'm Jan and it's great to be doing this show with you. Er, I think it's really great because I was once working with John Cage in Frankfurt when the Opera burned down. Ya know? The Opera in Frankfurt. Yeah it burned down. John Cage came out of the building and the only thing he had rescued was a tea pot. There he is, holding this tea pot and the Opera is burning down. So, you know, there's a kind of crazy thing here, with John Cage, the tea pot and here we are doing *TEA*."

We shuffle in our chairs.

Jan puts a videocassette into the TV, but before he presses the start button he starts on another tale about another composer. Is he on mind-altering substances? I can't help wondering. His

38

finger hovers over the start button but still he doesn't press it. *Come on, I want my coffee!*

"And yeah, I just want to say how thrilled I am to be here and that Tan Dun here has invited me to be a part of this fantastic project of *TEA*"

Tan Dun must want a coffee too because he says "No I didn't invite you, Pierre Audi did."

Surprisingly unfazed by this apparent put-down, Jan the video man comes down to earth from his self-absorbed ecstasy, presses the button and we are treated to about 20 seconds of out-of-focus coloured shapes.

"But this" he says in his something-fuelled enthusiasm (perhaps he's already had a coffee and is just ahead of the field), "is tremendously exciting you know because it shows that *digital images are organic!*"

There's a silence born of what I can only imagine is everyone in the room thinking at exactly the same moment: "what the hell are you prattling on about??!!"

Someone coughs. And then, mercifully, Pierre suggests a break.

Over coffee it turns out that in addition to the "organic digital" images taken at the airport (the first place you're bound to head to for organic digital images), they have been filming extreme close-ups of nipples of various hues and sizes to serve as landscapes. And there's talk of an intra-vaginal probe-cum-camera that will also be used to provide more scenic backdrops. Quite what the Japanese audience in the Suntory Hall, where we premiere this piece, will make of a six-foot tall image of an out-of-focus clitoris, God only knows. I suppose in its blurry digital-organic state no-one will realise. But this is the land where pubic hair is censored out with big black dots. Singers being singers, we're keener to discover the process by which the starring vagina was selected.

Our first true rehearsal is a music call with Tan Dun, who gets off to a bad start in my book by calling me Richard, the name of the errant tenor who originally got the role. I let it pass.

First music calls are always terrifying. Inevitably there's a wee voice in your head that idly speculates whether or not the conductor will really hate your singing. Perhaps the seeds will be sewn for a frosty relationship that will result in your sacking. Some conductors seem to make a habit of sacking people to

"encourage the others". More on that later. The fact that the conductor is also the composer merely compounds the fear. Luckily on this occasion he seems pleased enough and the fact that I have done my preparation thoroughly stands me in good stead. Which basically means I manage to sing the notes he had written in the right places. This role is definitely a heavyish one for me, with many more spectacular high notes than I am usually asked to dig out of an evening, so I am very aware that the ears of the management, especially the doubters, are tuning in to hear how I do. If I had to describe how this feels I'd say it's a bit like having your dad in the front passenger seat the first time he lets you behind the wheel of his car after you've passed your driving test.

The rehearsal ends and I go to an unbelievably long costume fitting. The random geometric shapes have taken on some form but they are so far removed from what could be described as normal clothing that I fear that we are being used as mannequins to parade the designer's whimsy, rather than he is helping us as actors to convey our characters. So what else is new? This is one of the bugbears of singing opera. It seems so often these days that people who actually take no part in the rehearsal process (i.e. designers) do their best to make your job considerably harder than it already is.
Ironically, if ever you raise the concern that your ultra-modern costume might not be very comfortable to sing in you are treated to the most old-fashioned of looks. So I keep my mouth shut and let the hordes of costume-makers fiddle and pin. The designer enters, gives a sour look which says "how could you possibly turn my abstract coloured splodges into this pile of shite?" and promptly starts dismantling hours of cutting and sewing until I look like the something a three year-old might have knocked out by randomly twiddling the knobs on an Etch-a-Sketch. He smiles in triumph and I make encouraging noises just to get the hell out of there.

We turn up for our first proper production rehearsal not knowing what to expect. I've worked with Pierre Audi on many productions – more I'm sure than any other singer – so I know that it won't be easy. I see one of my offstage roles as calmer-of-nerves for the rest of the cast of five, nearly all of them Audi neophytes, even though I'm secretly shitting bricks myself.

Pierre and I count ourselves as friends, which is remarkable given his abrasive directing style and my tendency to freeze him out when I get frustrated. He can be, without doubt, the rudest and most patronising director I have ever worked with, which is saying something. But I love him in a weird sort of way.

Rehearsal periods with Pierre have tended to begin in a number of ways. He used to emulate the techniques of various radical directors and ask his cast to play games. To someone who spends all day toiling at a desk or lathe this must be the most comical variation on the theme of "work" they can conceive. The sight of grown men and women playing tag or throwing a ball in the name of art could bring out the cynic in the most open-minded. And yet this is what we do. Mind you I've never been to a "corporate team-building workshop" - in thanks for this I offer up my first-born - and I've no doubt whatsoever that very daft stuff goes on there too.

The odd thing about game-playing is that it always feels as if it is going to be the most hideously embarrassing activity, and your insides churn at the prospect. Yet once you get going it is great fun, the quickest possible way to get to know your colleagues and the very best way to feel uninhibited with them. This last factor is very useful. Let us not forget that mine is a job where you are often expected to express undying love for someone you've only just met, who possibly owns a face like a camel and who speaks no common language to yourself except, if you're very lucky, the one in which you're singing the opera. You need all the help you can get to break down the barriers.

For the very first rehearsal of *TEA* Pierre declares that he wants us to run the whole of the first act (which is half of the opera) as an "uninterrupted improvisation". A palpable sense of terror falls on the room. Yikes. We all start double-checking bits of the score to see if we know it well enough for such a shocking endeavour. How can I describe what this prospect is like? Assembling an IKEA wardrobe with neither the instructions nor the comic Allen key. Being shown a pantry and told to knock up a soufflé without the aid of a cookery book. Being told to drive from Paignton to Thurso without a map. You get my drift. It's daunting but not dangerous. Well, not very.

For myself I decide to bring out of mothballs all my best Audi moves, gleaned from 12 years of working for him, and show off as much as I possibly can. I twist my body into strange distortions, crawl on the floor, grab other singers in peculiar and

unsettling configurations, and even manage to dribble and spit a bit, all the while singing my bollocks off. It's a nauseating spectacle, believe me.

The run, inevitably, breaks down many times from memory lapses but we stagger to the finishing line with Tan Dun's score and our brains in tatters and an overwhelming sense of relief that some of it wasn't as embarrassing as we had feared. Or so we tell ourselves.

At the coffee break, during which there is a dizzy and premature atmosphere of celebration, Pierre wanders over.

"Chris, I'm very impressed with your singing!!"

"Oh, gosh, well thank you."

Blimey.

Aha, cynic that I am, I wonder if he is wearing his director hat or his Management hat. As I've said, this part is more heavily lyrical than my usual bread-and-butter roles. Added to that, let's not forget that I'm singing this on Pierre's recommendation. All the other roles were cast by Tan Dun. To him I am an unknown. So I have to deliver the goods in order to reassure Tan Dun that Pierre wasn't making a balls-up in insisting on my casting. I'm the one who has to prove Pierre's judgement is good. Well, if Pierre is happy with my singing then I seem to have jumped that hurdle. But the big question still remains, can I deliver the crucial climactic C in the last act? There's a similar phrase in Act One and I've already done that one many times, but in that phrase the C is very short. I must draw strength from the success of that phrase. Yes, my whole sense of well-being has to rely on a few nano-seconds of music. How mad is that?

An odd thing happens at our next music rehearsal, when we finally get around to preparing the third and last act. It has been a long day and we are all tired. Towards the end of the rehearsal my dreaded phrase is getting closer and closer. I don't have anything to sing in Act Two, and by the time I do get to sing in Act Three I can tell that my voice has had enough for the day. It feels like curling up on a sofa and watching the telly. It certainly doesn't feel like attempting the high jump.

Shit. What can I do? I decide to mark – that is to sing at half throttle and if necessary down an octave - and this is entirely reasonable, given the amount of time I have spent waiting. No-one minds – some of the others are marking too.

And then out of the blue Tan Dun, with a thin smile says:

"Richard, I mean Chris. Can you just sing the top C out, full voice for me?"

Panic from me. I just know I'm not in the right frame to do it now, nor should I be expected to be. I make little protesting squeaks and pathetic gasping noises which I hope will send the message that this is beyond the call of duty etc etc and while doing so, Pierre (whom I hadn't even noticed sitting in the back of the room) chimes in:

"No, no, it's alright. I don't need to hear it. I trust Chris. I know he'll deliver it on the night."

Tan Dun cedes to this other authority and I immediately start to wonder what the hell is going on. Was this a sly audition? Tan Dun is due to leave us in a week or so, and I can't help but suspect that he has a Plan B up his sleeve if he is not happy with me in the first few days. There had been talk of Tan Dun bumping into a Chinese tenor at an airport and asking him if he were free. Apparently "not entirely" must have been the answer.

Or was Pierre wondering if I really do have a top C? Why was he there? He certainly hadn't been at any other music rehearsals, and I am left with the feeling that he is still having to fight my corner; that as far as Tan Dun is concerned I am an uncelebrated unknown.

Well, there's a big boost to my confidence.

Rehearsals for TEA settle into some sort of routine. Rehearsing an opera is not wildly different from doing any other job in that you turn up in the morning, work all day with a stop for lunch, and pack up at five-ish. We start late though, rarely before ten, because it's pretty useless trying to get a singer to make any sort of noise too early in the morning. We need time to warm up or we sound like Joe Crocker after a breakfast of gravel.

Of course when I say it's not wildly different I mean only in terms of schedule. As soon as I turn up at the rehearsal room I have to strip off all the clothes I only got around to putting on half an hour ago and climb into a rehearsal costume that loosely resembles what I'll have to cope with on stage. Particularly exciting in this department are the shoes. My left looks as if it has melted into a pool of goo, or if an elephant has squished it into a round plate. It doesn't look dissimilar to an enormous Fruit Gum. (The baritone looks as if he is wearing a giant Malteser.) My right shoe however is about twice the length of my foot and comes to a point so fine that you could happily use it to clean small infants'

ears. More of the designer's fancy. It's all very well, but in order to move I have to waddle about like Coco the Clown, and when you're playing a wildly jealous prince who wants to beat the living shit out of another prince simply because he has the hots for your sister (but for whom you also have the hots, which I'd say is more than a tad kinky), comedy shoes are not a great help in achieving everything you are trying to convey in the mean bastard department. I've already mentioned that I've worn this designer's shoes before and they were bizarrely long and pointy too; and just to create a fabulously fungal foot environment they were made out of brown cellophane parcel tape. My feet have never really recovered.

The movie *The Great Caruso* would have you believe that opera rehearsals take place on stage, everyone decked out in three piece suits and diamonds. The truth is that opera rehearsals, like all theatrical rehearsals, take place in dingy and draughty halls and warehouses. The Amsterdam opera house, the Muziektheater, is new enough and fancy enough to boast proper rehearsal rooms with all the mod cons, but because another, grander production is rehearsing in the main studio we are relegated to a small room, literally below sea-level, in the bowels of the theatre. And here we spend three weeks prancing around in leotards and pointy shoes, making sense of the piece, and basically beating the living daylights out of it.

There's not much one can say about rehearsals that, to be honest, makes for a riveting read. Tempers flare, there's often a lot of laughter, and more often a lot of crap. Rehearsals take as much time as you have. Some directors will insist on eight weeks, some are happy with three. Chances are that if it's an eight week period you'll be improvising for the first several weeks and won't sing a note. You'll be playing Cowboys and Indians, hugging each other or possibly taking your kit off. One thing is absolutely certain: no matter how long you've had to rehearse an opera, the last few days always will be fraught, the set and costumes won't be ready and the director will be screaming that he/she wasn't given enough time.

Unlike actors, singers are required contractually to have memorised their roles entirely by the time they turn up for their first rehearsal, no matter how long the rehearsal period. This can be supremely difficult, especially if your role relies heavily on other people for its musical structure. Imagine, if you will, being a

contestant on *The Weakest Link* in the admittedly bizarre situation where you have to give all the answers but no-one is asking any questions, and you start to get the picture. Every day, all around the country, there are singers pacing up and down at home going:

"1,2,3, *In a moment* 3,4, *Yes my lord!* 4, 1, *I saw her in the garden.* 1, 2, *She was...* oh shit, bugger, bollocks!

(pause)

1,2,3, *In a moment...*3,4,..."

And if you thought Anne Robinson was intimidating, try a few days being ritually humiliated by directors, and possibly even worse, conductors, and you would laugh in the face of such trivial condescension.

I visit the make-up and wigs department ("Kap en Grime" in Dutch) to sort out my hair. We've been asked to have Number One haircuts for the opera and so I decide to take the plunge and get used to it as soon as I can. Luc, the head honcho in the department, grabs an electric hair-trimmer and within a couple of minutes I turn from ageing git to ageing skinhead. I look like a billiard ball dipped in iron-filings. I'll have to buy a hat, but at least I actually seem to be in step with tonsorial fashion, possibly for the very first time in my life.

Back in the seventies I was a pupil (or strictly speaking, a cadet) at a public school run along naval lines. We wore naval officer's uniform and paraded every day. While the rest of the world was wearing its hair long, we had to follow naval regulations and have very short haircuts. You could spot a boy from my school in any crowd; we stood out like Oliver North in a bunch of *Status Quo* fans. Every week our hair was inspected and if it showed any inclination to touch our collar or our ears we were sent off to the school barber. He would visit each of the school houses in turn every week and disturb our evening studies with the snick-snack of his scissors and the buzz of his electric trimmer. I can't remember if he bothered to engage us in conversation. If not, then he was failing in his duty to prepare us for the hell of hairdresser conversation that lay ahead in our adult lives, but certainly any plea to go easy and just give a light trim were roundly ignored. So at least in one department he was doing his bit to educate us for life in the outside world.

Every year there was a sixth-form dance for which GIRLS were bussed in from another school. Conscious that we were probably the only under-18 year olds in the western world who looked as if we were living back in the 1940s we would be desperate to time our haircut so that it fell as far in advance of the dance as possible. This took considerable nerve, guessing when the time was ripe to volunteer for your last haircut so as to give it the maximum amount of time to grow back to a length that might, by the big night, persuade some GIRL that you were the hippest dude on the dance floor. Get it wrong and you would end up slated for a so-called trim at the worst possible time - on the eve of the dance - and look like a prick. Literally.

I remember timing it right. Not only that but I'd heard from some optimist that washing your hair actually increased its length, so I shampooed on the afternoon of the school dance. Then, and I wasn't alone in this, I went through the delicate process of arranging as many strands as would oblige to sit across the top of my ears. Throughout the evening – at which needless to say I wouldn't even pluck up the courage to ask one GIRL to dance – I would be constantly checking to make sure my hair was actually over the top of my ears in the hip-dude position. I must have been a truly pathetic spectacle.

I used to spend the holidays doing little else but growing my hair so that people didn't give me funny looks. It doesn't make for an exciting vacation, believe me.

For some reason I have never fathomed, I once let my mother persuade me to have my hair cut during the holidays. I think she promised me it would just tidy it up. How could I? It was by now well over the top of my ears. I could barely see through my fringe. I almost felt normal. Another two weeks and I might almost have been considered trendy. But after the haircut, when I saw my neat, short hair and the devastation of all my careful husbandry I actually burst into tears.

As soon as I left school I let my hair grow with a vengeance and wouldn't you know, at precisely the same time, long hair suddenly went out of fashion. At least by then I was used to looking to the rest of the world like a prat. Now I just looked like a hairy one.

Back in rehearsals and we're chugging along from one to the next but with run-throughs becoming very imminent. Pierre complains that my only and very short aria is "too sung" and I go

ballistic on the inside. I thought the issue had been whether I could sing it at all!

Rehearsals move out to a film studio in a business park on the outskirts of the city where they have built a mock-up of the stage on which we'll be performing. The studio we have been in to date is too small and so far we have had to busk around certain passages of the opera. This change of venue adds another hour to our daily journey time that turns up the fatigue and irritation dials a few notches.

The acoustic makes singing a grisly experience. It's like singing into a nappy; everything gets soaked up. The studio is dirty, the air is stuffy, and of course there's no daylight.

Whereas so far we have been rehearsing on the floor, now we have to cope with steeply-raked ramps made from MDF. I make my first entrance and my pointy shoe catches the fringe of my long costume, taking the fabric underneath the sole. My next step might as well be on ice, as there is no friction between the fabric under my foot and the MDF ramp, and as I am trying to walk on a 20 degree incline I fly arse over tit in a spectacular arc and land flat on my back. Bang! The rehearsal stops. Chorus members rush over in concern.

"What went wrong Chris?" yells Pierre, even though I would have thought it was pretty obvious. Of course, then and there I want to throw a diva fit and demand that the shoes, the costume or the MDF ramps be axed, but I know I'll be on a hiding to nothing. None of these things is going to happen, but a bit more sympathy from the director's chair would be welcome.

The rehearsal carries on in much the same vein. Problems arise at every turn. You start to see the problems coming before you get to them, but it's no use pointing them out before they actually arise as Pierre doesn't seem to want to solve them in advance. He's too busy sorting out the current problem. So the crisis you have foreseen duly happens and you get yelled at for not fixing it. If you show a bit of initiative and do something to avert the impending disaster you are scolded for failing to do the moves you rehearsed in the smaller studio.

You can't win and you can't avoid the director's scorn. You have become a punch bag that keeps bouncing back for the next blow. It feels as if all the work we have done in the last three weeks has been for nothing.

Slowly but surely the production starts to re-mould into something possible and credible. My biggest problem seems to be in my first scene. I have to do a lot of running and jumping in a very voluminous costume, carrying a long pole with a giant cone at its end – for reasons beyond my grasp – and I find myself panting and gasping so much that I'm unable to sing well, if at all. The real trouble is that the more I panic I am going to run out of breath, the more breaths I try to take. But this only makes matters worse as I become over-packed with air and need to release it, which makes me pant even more. It's going to take weeks to retrain myself to take fewer breaths and I'll be lucky to fool my body into doing the right thing by the first night.

The work becomes an obsession awake and asleep. I find myself watching films on TV and wondering what I can nick from the performances to use in my own. I wake up in the middle of the night and practise the facial contortions I have to do to produce the top Bs and Cs. Without getting technical it's all about sending the voice into a different region of your head and to do this I have to imagine I am sending a very focussed beam through the top of my upper gums while turning the inside of my mouth into a letter-box. It sounds nuts, but that's just what has to be done. Bizarrely, I find that it is possible to practise this mind-set without making any sound whatsoever and it seems to help. In the opera I have a long stretch of silence before my final top C and I use it to imagine driving a nail up through my hard palette and into the tip of my nose. Weird but it usually does the trick.

We have a make-up try out for the designer. Now I have my crew-cut they can paint a big white splodge on the left side of my head, about five inches in diameter and covering half of my ear, and in the middle of that they glue a patch of bushy black hair. I look like someone who has been shat on by an albatross that has failed to fully digest a small hairbrush.

The designer looks thrilled.

The bass, who plays my dad, the Emperor, whispers to me: "You look like a cunt."

I fear it, I promise you

Tokyo

I fly into Narita and am met at the airport by a young employee of the Suntory Hall who clearly thinks it would be "cool" to dye his hair a putrid pink. He bows.

"Ah, Mister Girrett, I was worried about you. You take so long to come from plane!"

"Yes, well, the immigration queue was enormous! (and I had an overwhelming need for a good sit down on the loo after the interminable flight from London)" I explain, leaving out the second bit.

My grinning greeter gabbles campily into a shiny pink phone and we slide off to another part of the terminal to meet up with other members of the cast who have flown in from Amsterdam and Paris. The poor buggers have been waiting an hour while I relieved myself and queued to get into the country.

Assembled with our luggage and our Number 1 haircuts it looks as if a Bruce Willis Lookalike Contest has arrived in town.

Arriving at rehearsal the next morning I don't know whether I'm dead or alive. I do know it feels as if there are a couple of sultanas where my vocal cords used to be. I've downed coffee, corn flakes so pricey you could present them to your wife instead of jewellery (I'd love to see how that would go down) and an earthquake-proof croissant, but they haven't helped relieve the symptoms of jet lag.

Talking of earthquakes, there is a survival kit in my room, a normal feature in Japanese hotels. I'm not sure what to do with it but it does look the business. Its presence manages to be both disconcerting and reassuring.

We meet in a small rehearsal room. Tan Dun is with us for the first time in several weeks, and sitting round a piano we potter through the opera to remind him how it goes. Everyone is complaining of jet lag and no-one wants to sing. Dowsing the dried grapes in my throat with bottle upon bottle of water helps a bit, but I know it would be foolish to try to sing out. Besides, my ears are still deafened by the flight so I can't get a true aural picture of my voice. This is always very disturbing. There's nothing for destroying your faith in your singing like a wodge of seemingly immovable ear goo.

We weren't supposed to rehearse at all today. They were going to give us 48 hours to acclimatise. But Tan Dun has to fly to Singapore for a meeting with Bill Gates – or so we are told - so the plan is to have this piano rehearsal and then nothing for the next 48 hours while he is away. We speculate in secret how many bits of the opera will appear in the next version of Windows.

I just want to make it through this morning without sustaining any damage and then get myself together during the next two free days. Light relief comes when we are handed printed sheets titled *Dairy Schedule*. (10.30 to 13.30: Cheese. 2.30 to 5.30: Milk and Butter?) Benny Hill would have been proud.

I hate and loathe the last days of rehearsals. Once the production gets on stage the whole thing turns into a nightmare. Everything that can go wrong invariably does. All your best-laid plans seem to dissolve before your eyes. That move, which was so swish in the rehearsal room and which seemed to get you across the stage in three easy steps, now seems to take fifteen and makes you look like a panting drum-majorette plonked in the midst of a state funeral. My voice, never huge at the best of times, suddenly feels the size of a newt's, and a particularly small newt at that. This newt would be the newt that's chosen to play the infant Jesus in a newt primary school's nativity play.

Tempers, not least my own, fray. It is hard to feel positive about anything at all. The set, now erected for the first time in all its bleached, wooden glory looks rather as if someone has left the bits of a self-assembly kitchen lying around. The highly-paid ex-hippie video man doesn't seem to have produced anything at all. Where are all the nipple close-ups and intra-vaginal shots we have been panting to see?

And as for the costumes.... They are finally complete but lest we spoil them we are not allowed to wear them and get used to them. What are we, clothes horses or singing actors? My first costume, the geometric jump-suit, I can see on closer inspection is made of about fifteen differently-coloured layers of net sewn together into a single, quarter-inch thick fabric. The effect is clever to look at but will be hell to wear - like prancing around in several cellular blankets and a duvet. I reckon that by the time I have got it on I will manage the rare achievement of looking like not only Dorothy from *The Wizard of Oz*, but also the Scarecrow and the Tin Man, all at the very same time. What is more, this

bizarre amalgam is dressed for a skiing holiday. My second costume is staggeringly huge with vast cubes where my arms should go. I'll look like a cross between Jessye Norman and an enormous Yorkie Bar.

This sort of thing doesn't help my mood. All that seems to lay ahead is a week of solving silly problems. All other notions – of trying to create something, of developing a drama – become hostages to the technicalities of getting through the show. All that seems to become important is not to fall over. This is before the orchestra has even arrived. As soon as they are involved then the focus of problem-solving moves to making sure that we can see the conductor and keep together with the orchestra. Suddenly bits which were fine with a piano accompaniment fall apart with the band. All refinement disappears in the interest of singing as loud as possible in the vain hope of not being drowned.

We rehearse the show bit by bit, rearranging positions to fit the new space and sight lines. Our soprano, Nancy, has gone down with a cold so the assistant director, Jacqueline, stands in for her while the assistant conductor bawls his way through her part. At least this ad hoc arrangement takes the heat off us and lightens the mood. Tan Dun decides to sit in the auditorium rather than conduct the piano rehearsals. He appears to nod off from time to time and disappears before we reach the end.

The next day is more of the same, a seemingly endless round of problems and corrections. Although the rehearsals start in the afternoon I am not out of bed and dressed until noon. I would feel guilty about this if I didn't know that all of my colleagues are doing exactly the same.

Just when I feel on top of the newly-sorted problems of staging we are allowed to wear our costumes for the first time. The weirdo shoes I have had to endure for so long in Amsterdam become an even greater nuisance out east. The pointy shoe, my particular bête-noir, keeps getting caught in my voluminous costumes and I suddenly find myself unable to move, which it would be something of an understatement to describe as a fucking hindrance!

Suddenly Pierre decides that we should cut all the silly shoes and go barefoot instead. While this is a tremendous relief it radically changes the way I will have to move. Well it would, wouldn't it, if you had spent five weeks getting used to prancing

around with an 18" long right foot? The new issue becomes the innate slipperiness of the steeply-raked, varnished wooden platforms. In the heat of slaving over a hot opera I find that the soles of my naked feet are getting really rather sweaty. It feels like I'm descending the north face of the Eiger with nothing between me and the smoothly varnished set but a seemingly uncontrollable stream of underfoot perspiration. What makes it worse is I'm leaving the stuff all over the stage like some immense slug trail. I don't know which is more unsettling, the constant worry that I am going to slip up and land on my bum or my embarrassment at this podiatric outpouring.

A morning and afternoon is spent in a Sitzprobe with the NHK Symphony Orchestra. Sitzprobe is German for "sitting rehearsal" and has been adopted by we Brits as a term for a rehearsal with the orchestra where you just stand and sing without any wandering around or acting. Interestingly, the French call this sort of rehearsal an Italienne, which gives a flavour of the opinion the French must have of the way Italians tend to rehearse.

Female singers invariably doll themselves up for Sitzproben; even those who normally wear jeans and T-shirts. Out of the blue they appear in short skirts, careful make-up and big hair. The reason? They would say that it is relief that at last they can wear decent clothes after weeks and weeks of grubby rehearsal togs, but really it's so that the men in the orchestra – particularly the brass - will think of them as "a bit of alright". It does no harm to have the orchestra on your side and the easiest way to get this is to flutter your eyelids.

Nancy is still ill so she doesn't appear, and the rest of us are still jet-lagged and discombobulated by having to sing in the morning, a trial at the best of times. So we sing as little as possible and mark our way through. Besides, we have a third rehearsal back on stage in the evening so we are anxious not to overdo it. This is the first time we have heard the opera with orchestra and it all sounds hideously, horribly loud.

At lunchtime, poor Nancy, hoarse and runny-nosed, suddenly rolls up. She has been asked to come along and listen. Outraged, we singers shoo her away and order her back to bed. If she sits in a rehearsal all afternoon it won't be long before Tan Dun suggests she sings something and she'll end up worse than she already is. Besides, none of us is keen to be within infecting distance of her. Thankfully, she disappears and we breathe again.

Everything melds into a relentless and exhausting routine; get up, get dressed, go to theatre, get undressed, get dressed, rehearse, get undressed, eat, get dressed, rehearse, get dressed or undressed (it doesn't seem to matter any more) go back to digs, eat, phone family if possible with the time difference, sleep. Badly, all of it. Including the dressing and the phone calls. All the time, the pettiest of the opera's themes plays over and over in my head until I'm sick of it. Why can't we just get on and perform the bloody thing?

All the fantasies I have had about getting out to Kamakura and seeing some serious temples or watching some Kabuki dissolve in the face of the god of self-preservation. I have been to these places before and I have a hunch I'll be back another day, so I am not heartbroken; but it would have been good to get out. My abiding memory of Kabuki, which I saw when I was all of nineteen, is of huge amounts of noise coming from backstage during the plays. As different plays are performed throughout the day, I guess they were building the set for the next show. It was all in Japanese and I have no idea what they were saying, but it seemed to go something like this:

Kabuki Actor 1: "So, you come to taunt me Vixen of the North? (BANG, BANG, BANG, BANG) Did my father not slay your brother? (SAW-SAW-SAW)"

Kabuki Actor 2: "Yes indeed (THUMP, THUMPITY, THUMP), and my tears will forever water the lotus flowers (CRACK, THUMP, RRRREEEEEEE)"

(That last one was a drill, just in case you couldn't work it out.)

I also remember struggling with a particularly beaky cold octopus that was winking at me from my bento in the lunch break. Being a culinary neophyte at the time I believe I gave him a miss and concentrated on the cold noodles.

No sooner has Nancy reappeared though than our Chinese mezzo calls in sick. It looks as if we won't have a complete cast until the last couple of days, but hey, that's the wacky world of opera!

Somehow we make it to the final dress rehearsal which we'll show to a non-paying public. Unwavering in my routine, I manage to spend the day doing bugger-all save a short stroll around the block and a spot of grocery shopping. You'd be

amazed how knackering such minor activities can seem when you are obsessed with saving every gram of energy for the evening's performance. All domestic chores, especially the washing-up funnily enough, get put off in the interest of saving energy. A visit to the loo seems so Herculean a task that it has to be offset with a brief lie-down. A cup of coffee seems all very tempting but I worry about the dehydrating and stimulative effects. I stick with large quantities of water and fruit tea.

The day grinds by. Tonight's unpaid performance forms just one tiny part of the dress rehearsal process. The whole day is a dry run for the day of the actual premiere. Why can't it be ten-thirty p.m. already and time for the curtain calls? Perhaps the theatre will burn down and the whole thing will be cancelled! I just want it to be over, the waiting, the anxiety. I feel hungry without wishing to eat, tired yet unable to sleep. All day is spent in giving myself pep talks: *You have to go out there and show off! The moment you forget that will be the moment you sing less well.*

Don't, whatever you do, think that you have to prove something. If you think that then you're assuming that you may fail.

Don't even ponder for a moment the possibility that some evil bastard in the audience might actually be waiting for you to fail.

Once you start thinking about that any tiny blemish in your singing - and let's face it, there are bound to be quite a few of those – will feel like a complete and utter disaster.

You'll be imagining the evil bastard, who's probably a CRITIC anyway, turning to all his fellow bastards and announcing to them: I TOLD YOU HE WAS NOTHING SPECIAL!!

Once you start going down that path you'll be well and truly screwed.

Damn, you have.

Oh bollocks, you are.

Screwed, that is.

Surprisingly, I make it to make-up, into my costume and onto the stage, though not without wishing the floor would open up and swallow me. It goes pretty well and the small audience – mostly friends and family of the orchestra – receive us politely and warmly enough. Japanese audiences are not pre-disposed to hysteria so there is nothing more than a decent amount of clapping, but that will do. It seems fair enough to assume that while the premiere will not exactly be a sensation of earth-

shattering dimensions, we will be able to leave the theatre with a modicum of self-respect.

Two days later and it's the morning of the First Night. So, how to spend my last hours on Death Row? Let me see, what are the alternatives? I could go on a five-mile run, spend the morning studying a Wagner score, meet a high-flying agent for a six-course lunch and a couple of bottles of claret, then spend the afternoon practising the piano before heading to the theatre for an hour's warm-up and tonight's show.

Or I could stay in bed all day and rise only to eat, bathe or empty either bowel or bladder.

Hmm, a toughie.

Damn, I've forgotten to buy good luck cards and disposable gift-ettes!

Bang goes my plan of preference. Now I'll have to spend most of the morning in idleness, eat a significant breakfast at around noon and venture out in search of luck-evoking tat at one or so. Then, assuming I'm successful it will take me a good half hour to write my cards which will leave me so exhausted that I'll have to lie down for another hour. At around five I can fix myself a simple bowl of mega-expensive pasta to get me through the show. Any later and I'll do nothing but burp all night. Yup that plan doesn't sound too bad. Especially as it's pretty-well exactly what I and all the singers I know do on every performance day.

First though, I have to psyche myself out of bed.

See, I tell myself, *here you are on the day of this world premiere and you've made it through. YOU'RE NOT EVEN ILL! Just think, you can go out there tonight in the knowledge that there's no reason for you not to be in stonkingly good voice. How often does that happen, eh?*

Vitalised by this pep talk I'm up and actively into one of the day's essential activities. No, not that. I mean resisting the constant temptation to check my voice and clear my throat every few minutes, a ruinous habit I used to have that bordered on an addiction. I believe I have kicked it now, but on days like these it's all too easy to slip back into old ways. A little light humming in the shower is all I'm allowing myself today.

After knocking up a fairly respectable impersonation of a Full English Breakfast and leaving all the dishes piled in the sink to deal with at a later, less stressful date, it's time for some light exercise and the purchasing of first night gifts.

In the league of present buyers, I am well at the bottom of the fourth division. There are those up at premier level that will happily fork out hundreds of pounds on watches, handbags, cashmere cardigans... you name it, they've given it. Me, I do a card and if you're lucky, something silly. I never do flowers. The advantage of giving something silly is that you have no expectation of its future other than it being almost immediately chucked into the waste bin where it really belongs. I can't tell you the number of nice little notebooks and trinkets, mementoes and 'objets' that I have carefully packed and taken home, only for them to end up spending a few years in a neglected drawer before making their final journey to the dustbin.

I walk a few blocks to the Roppongi district which is buzzing with lunchtime energy. I envy the salarymen their "normal" jobs, wishing I too could be heading out for a relaxed lunch before a dull afternoon at the office; which is a pretty silly thing to do as I have no doubt that they would far rather be doing something as unusual as what I get up to. The grass can only be so much greener.

If I just didn't have to worry so much! Of course it's ridiculous to fret; no-one's life is in my hand. If it doesn't go well, I won't die for god's sake. So why worry so much? Obviously the bottom line is that if I don't do well, I won't be re-hired and if I'm not re-hired how will I pay the mortgage or put food on the table? There are plenty of excellent singers at the moment who have too little work. The whole classical music business is on the verge of meltdown so why should I be spared?

It's more than that though. It's - oh yikes - my self-respect that's at stake. What's the point of going out and making art, of creating something new, if you find yourself not doing it as well as you know you can? That's where the neurosis sets in. That's why any tiny, barely audible vocal glitch upsets so much. That's when the voice in your head says *if only you hadn't had that extra cup of tea (or walk, or Malteser, or handshake with the guy who was sniffling...) that might have gone better!!*

Oh well, I'll just have to get on with it.

A very tacky-looking pound shop - I'd love to call it a yen shop but at 195 yen to the pound that would be plain silly - catches my eye and I saunter in. With all the originality I can muster I'm on the lookout for anything at all to do with tea. Aha, tea strainers. 60 yen each. Cheap too - even better. I pull ten off the hook and search for cards, which are curiously difficult to find. It's the

same in the Netherlands. There are only so many photos of tulips that a man can take and they are already pushing the limit over there.

However, back in Tokyo, I pick up a pack of notelets that have something Japanese emblazoned across them. No idea what it is. It probably says "condolences on your loss" but I'm pretty confident that even my Chinese colleagues won't know that. Surprisingly no-one bats an eyelid when I pay for ten tea strainers. Perhaps they assume there's a shortage back home where I come from.

It's a warm day so I don't want to stay out too long. Besides, I haven't been in bed for a couple of hours so it's about time I headed back and had a siesta.

Two hours to go and I've had my ritual pasta, going easy on the garlic and parmesan, and I've written my cards. "Hoping *TEA* isn't a STRAIN!" in all its feebleness, is the best quip I can manage.

I get to the hall in plenty of time and already there's a neat array of cards and gifts. The Suntory boss has given us all small pots of green tea powder and exquisitely crafted bamboo whisks that I can already predict will be used just once, but which make my flimsy 30p strainers look decidedly naff. I distribute my meagre offerings around the dressing rooms and pad up to the make-up room to be transformed into Prince Birdshit-Head.

Various worthies appear and proffer good luck, and Pierre, as edgy as the rest of us, gives me some final notes. The only notable absentee is Tan Dun who, oddly, doesn't come round to wish anyone good luck. The time grinds by. The Stage Manager gets on my nerves with his calls on the tannoy:

"Fifteen minutes until the world premiere of TEA."

"Ten minutes until the world premiere of TEA."

"Five minutes...."

YES, WE DO KNOW IT'S THE FUCKING WORLD PREMIERE, THANK YOU!!!

There's just time for one last glug of water and one final pee before I climb into my Kandinsky-esque space suit inside which urinary relief is not an option. Isn't there a law against that? Then on with the enormous coconut fabric Monkey King wedding gown (don't ask), and I'm off to the wings to collect my big pointy cone on a pole, as you do in the course of a normal day's work. Not

surprisingly my sphincter is wracked with nerves so I have to let loose a long but sadly unsatisfactory fart before I go onstage. My cue comes and there's no escape; I have to make my entrance.

then all is well

Tokyo.

It goes quite well, all things considered. I don't fall over, which is a start. I don't make any mistakes. Vocally it's not up to what I know I can do, but I would like to meet the singer who is totally happy with his first night performance and who isn't a total dickhead. At least I negotiated the cruel tessitura with some success. I can tell that it's one of those roles that doesn't capture the audience's imagination, but I guessed that some time ago. He's like Pizarro, the bad guy in Beethoven's Fidelio – a pig of a man and a pig to sing by all accounts (I wouldn't know personally – it's a baritone role). There are some baddies that come over very well but Prince Dorothy-Tin-Man With The Hair Of The Albatross Poo-Poo isn't one of them.

In the wings after the curtain calls there is the usual display of hugging, back-slapping and crying of darling-you-were-wonderful. After we have changed there's a reception for a few hundred so-called worthies. There is even a local celeb couple who, even though we haven't a clue who they are, simply exude celebness. The Posh and Becks of Japan, she's an actress, natch, and he's a rock drummer. How passé.

Wine flows, sushi and nibbles abound, and terminally dull speeches are made. Tan Dun waxes lyrical for quite a while but notably fails to mention the contribution of the singers, something that doesn't go unnoticed by the rank and file, I can assure you. I can only take so many of the platitudes being heaped out in bucketloads, and leave before I get angry with boredom. I'd rather get back to the apartment and speak to my family.

After the second performance - yes, all this excitement for just two performances - the entire company is treated to a beery meal in the back room of a local restaurant. We all get lightly pissed. There's talk of what has passed and what is next, but my heart isn't in it. All I can think about is getting on a plane in the morning. I haven't seen my wife for six weeks and my son for three, and tomorrow I get to go all the way to Washington DC, where she's singing and to where he's on his way too.

Tonight I've had it with opera, singing, TEA, Tokyo, the lot. I just want to walk back to the apartment and pack.

A couple of months later and we're back in Amsterdam. It's the week before Christmas and we're rehearsing *TEA* again for a run of five performances in the New Year.

It's very cold and within forty-eight hours of my arrival, I come down with a flu virus that's doing the rounds. I end up rehearsing for a total of five hours in the whole week. The rest of the week I spend in bed desperately trying to get better.

In the few hours I am in the opera house I hear a rumour running around that we will be doing the show in Shanghai in August. I've never been to Shanghai and the extra dates would be useful. At last, a gravy train might finally be leaving the station.

I go home again for the Christmas week and return to Amsterdam on New Year's Day feeling that I am 80% recovered. The next morning is a *Sitzprobe* with the Netherlands Chamber Orchestra. Just before we start, we are handed Christmas cards from the boss of the project in Tokyo. Mine says:

I wish you every success for European Premiere of TEA! I am so sorry you will not be joining us in Shanghai but we have to use a very famous Chinese tenor – he also runs the Macau Festival.
This is a political decision and does not reflect on your art, and I am very unhappy with it.
Happy Christmas!
Keiko

Well, this is a blow.

Mouth open, I show it to my colleagues, who it turns out know already and assumed that I had already been told. The more I think about it, the angrier I become. Tan Dun clearly knew from the get-go but said nothing. Nothing at all. Well, no-one did. Did they think I'd never find out?

It certainly looks like the only reason I am being dropped in Shanghai is because I'm not useful enough to Tan Dun or to the exposure of his opera. Either that or I'm really crap in the role and they haven't the heart to say so. The Famous Chinese Tenor's directorship of the Macau Festival must be pretty useful in the back-scratching department and I have nothing to match it. Back in Tokyo, Tan Dun said to the orchestra: "we all want to be rich and famous" – what every orchestra wants to hear I'm sure - and I suppose I can't help him on that path.

I feel like a pariah. No-one can quite look me in the eye anymore. Or they shower me with just a tad too much sympathy.

We sing through the opera, which is still too loud, I with the thought running through my head that Tan Dun can take his precious opera and stuff it where the sun doesn't shine.

Next day I speak to Pierre about it and he is indignant and appalled. "I am very unhappy about this Chris, very unhappy indeed. We have worked so hard to make this show, to slow-cook it, and now he wants to stir-fry it in a wok. It is appalling. I will do what I can!"

I go into "sod-it" mode where I just want to ignore the politics and get on with doing the bloody job. Surprisingly, it's a good mode to be in and I start to regain my confidence. Suddenly I don't care what anyone thinks anymore. Let them get someone else and let's see how *he* gets on with Prince Poo-Head.

Still Tan Dun says nothing to me.

A few days later he summons up enough courage to sidle up to me in a coffee-break. Somebody must have said something to him.

"Chris, this is just temporary and political. I admire so much what you have done. It is very special. You will be back to sing *TEA,* I promise,"

I tell him I understand the reasons he is replacing me - meanwhile giving him a look which I hope says that I can see right through him - but that I don't respect those reasons. And we go back to rehearsal.

Of course, the one thing I won't acknowledge is that firing me might be the best decision for the opera; that the role really isn't ideal for me. That would be far too mature and rational. I can't see beyond the simple fact that I "created" the role and that makes me feel like its sole and very proud proprietor.

Unexpectedly, The Very Famous Chinese Tenor comes to see the last two shows in Amsterdam, where I have to say I'm having some pretty good nights of singing. (Believe me, it's not often I say that.) He goes to see Tan Dun afterwards and tells him that the range of part is too difficult and he isn't sure he can sing it as it's written. Also he feels the character is too unsympathetic and could do with an extra aria or two. While adhering the poo patch to my head one night, Luc, the head of the make-up department lets slip to me that he's convinced there's no way on earth that The Very Famous Chinese Tenor is going to shave off his abundant and Baywatch-esque locks for the production, let alone glue anything on top of his bonce. Though this makes me smirk, I really don't know what I'm feeling any more. Anger,

Schadenfreude at the mess they seem to making for themselves, jealousy, resentment..... a cocktail of all of those. It all looks as if things are going to become a little tricky with Mr Very Famous Chinese Tenor on the crew.

After the run and back at home I hear on the grapevine that Tan Dun and the management are trying to find a way to make the part more appealing for the Very Famous Chinese Tenor, while Pierre is saying that if the opera is changed he won't have anything more to do with it. They're heading for a stalemate.

Come the summer I go about my other jobs - Montpellier, Berlin, the Proms - all the while wondering if the phone will ring with the surprise news that the VFCT has changed his mind and I'm needed straight away on a plane to China. But before I can discover if my hunch will prove right SARS rolls into Shanghai and they have the perfect excuse to cancel the whole thing; which they do with, I imagine, a huge cough of relief. Now they can stick on, say, a good ol' fashioned *Madame Butterfly* and everyone, especially the VFCT, will be happy. Especially as he can keep his hair.

A few months later my agent rings to say I've been asked to do *TEA* again, this time in Lyon. I'm really not available unless I can do it with no rehearsals at all. Nor is pretty-well anyone else, including the production team, but they still put all our names on the cast list when they announce their season. This seems like an act of desperation. It does go ahead eventually but with an entirely new cast and in a new production.

Tan Dun wants to get a DVD out of the Tokyo premiere. It went out on Japanese TV when we premiered it at the Suntory Hall, just for that added *soupcon* of pressure, so he has tapes; he just needs permission from his cast. Suddenly I am being told how wonderful I was in Tokyo and how powerful my performance is on the recording. I'm simply the bee's knees. Everyone else, I am told, has consented to the release of a DVD. "Go on Chris, how about you? It will be such a big thing for you." (I might add that the fee on offer is a paltry buy-out of $250). I fall for the flattery and say yes.

After a few more months *TEA* is revived in Amsterdam and despite being told how "extraordinary" I am on the DVD, I'm totally out of the frame now. After the Shanghai fiasco I'm told Tan Dun feels he "owes" the VFCT the opportunity to sing his masterpiece.

Over in Amsterdam, at the end of the revival run, The Emperor, my old mate Stephen, is asked by Tan Dun to convey to me a few copies of the DVD. Stephen goes to his dressing room and collects them.

He says to Tan Dun: "Aren't you going to write something in one of them for Chris?"

"Oh yes, of course" and he tears open the cellophane and scribbles some words in the inner booklet.

A month later, Stephen drops the DVDs off at my house. I open the copy that is missing its cellophane. Inside is written:

Dear Chris,

It's so unforgivable to work with you,

Miss You!

Tan Dun, 2005 Jan 4

Unsure exactly what Tan Dun is trying to say, I email him to say all kinds of water-under-the-bridge, let-bygones-be-bygones stuff. Brown-nosing, in other words.

I never get a reply.

must I speak now?

Weymouth. 1982

I've been on tour a couple of weeks with Opera 80. It's a small company. Twelve singers doing two operas. *Die Fledermaus* and *The Marriage of Figaro*. Five shows a week, usually three Strausses and two Mozarts, in two towns a week, for eight weeks in all.

The rule is that the night you're not singing a major role you sing in the tiny chorus. I'm doing Basilio in *Figaro*, and Alfred in *Fledermaus*, but in the Strauss, because of the tiny size of the company, I have to don a wig and play a Canadian party guest in Act 2, when Alfred is normally doing the crossword in his dressing-room. Curiously, I get more laughs doing the Canadian party guest than I do as Alfred.

I'm also the understudy for Eisenstein, though I'm being a bit remiss about getting the role under my belt, what with everything else I have to do. I'm banking on Michael, the guy I'm covering, being as solid as a rock and never cancelling.

For all this I'm on the Equity minimum of £85 per week. I'm the baby of the company and greener than a Wagnerian hero's tights.

The most significant thing I have learned so far is the difficulty of finding anywhere in Britain that will sell you a sit-down meal before a show. Nothing opens before 7 and that's when I have to be in the theatre. The only exceptions are Chinese and Indian restaurants but they are the last cuisines I want to face before plunging on stage.

Tonight it's Tuesday and it's *Figaro*. My easier night. Just Basilio to do - some recitative and the trio in the first Act, the finale of Act 2, Act 3 off and then the finale of the whole opera in act four. I've had an understudy rehearsal today, bluffing my way through Eisenstein rather badly, and I'm feeling a bit ashamed of myself.

It's the witching hour. Six o'clock and Weymouth is dead bar a few opera singers wandering around in search of something to eat indoors. It's late February and Fish and Chips on the prom is not a realistic option.

We give up our search and end up back at the theatre in the front of house bar where we order anonymous-looking food that is exhausted by a day under hot lamps.

For Pat, the Roselinde, it's her night off. All she has to do is make a couple of brief appearances as a bridesmaid. She's in the mood for a pint. Mike's there too, and another Mike. They've got even less to do.

"Chris, can I get you a drink?" says Pat.

Oh what the hell. I've done several Basilios now. It's a Tuesday for god's sake. Who's going to be in? A bunch of pensioners who'll think it was all lovely even if we went out there and farted our way through. I've had a bad afternoon. I'm bored, I'm cold, it's going to be a dull evening. My voice feels tired and a bit husky too after an afternoon of singing something I don't know well enough. A beer might perk me up, put some gloss back on my voice. It'll certainly take my mind off it.

"Yes, ok, I'll have a Guinness. Ta. Just a half."

Pat brings a pint.

"Oh Christ, oh well, sod it."

I drink the pint.

It would be un-gentlemanly not to buy my round, so I get one in and, enjoying the warming, releasing effects of the stout, I have another pint too. Besides it helps the horrible food go down.

We're having a laugh. Stories of Glyndebourne chorus. Banter. Chit-chat. It's fun.

"Christ! Is that the time? I'm supposed to be in costume". It's ten past seven and in our conviviality I've failed to notice the bar filling with punters in their sports jackets. ("Oh Brian, you're not going out to the theatre dressed like that are you? Put on your sports jacket, the nice one, and that woollen tie of yours we got at the National Trust shop. It is the opera after all.")

I hurtle backstage, first into the men's dressing room and second into my tights, feeling full of bonhomie. Here I am, a man of the theatre, out on the road, doing my thing. Ah there's my buddy, Eric, the Count.

"Goooooood evening Eric. How are you doing?"

"Fine thanks. You're very jolly. What's up?"

"Oh nothing, just had a pint out front with some of the others. Actually, I feel a tiny bit pissed but what the hell, eh?"

Half an hour later I'm in the wings with Eric. He makes his entrance a minute before I make mine, the Count's advances to Susanna being interrupted first by a line I sing off stage and then by my entrance.

He's about to go on.

"Toi toi toi" I whisper beerily.

"Cheers. See you out there."

On he goes. My cue comes, I sing my offstage line. Hey the voice liked the Guinness. It feels pretty good and clear.

I'm on. I slimeball around as usual. Everything seems warm and fuzzy. But somehow that's helping my oiliness as Basilio. I feel bolder, nudging the timing of the recitative in new directions. This is good. Hey, I'm cooking tonight.

The Count pops out from behind the chair and we're into the trio. I'm milking every look and glance. I'm firing on all cylinders.

Cherubino is revealed and I'm camping it up rotten. This is such fun!

And then, suddenly, the Count and Susanna are looking at me oddly. There's a hint of wide-eyedness about their look, of expectancy. The Count is crossing his arms as if to say "Yes??". I know what they mean. Something's not right. I'm fixing them back with a camp, unctuous grimace worthy of the finest Basilios. Something's missing. Someone should be singing shouldn't they? Isn't this where we all slowly step downstage for the final few lines? That's certainly what I was about to do.

Oh fuck, it's me. I've forgotten Basilio's surprise interjection.

I glance at the pit and Nicholas is conducting with his mouth open, his head rocking back and forth to the score to see what idiot has screwed up. The orchestra is playing but it sounds a bit pointless at this particular moment without a voice to accompany. They know how it goes too and I'm sure I can see heads turning from the pit to see what the problem is.

I stumble back in mid sentence, singing complete nonsense, and we crash on to the end of the trio, Basilio now a sweating, deflated, beery shadow of his former self, all fluster and no menace.

When I get back into the wings I'm crestfallen. I apologise profusely. Luckily my colleagues, my friends, find it funny. Not me. That's it. No more drink before shows for me. Ever.

as true as truest horse

Amsterdam

I'm here to sing in a piece, *Rosa, a horse opera*, devised and directed by the film director Peter Greenaway, who famously made *The Cook, The Thief, His Wife and Her Lover*. The music, which is terrific, tricky and funky, is by the Dutch composer Louis Andriesson, whom the Dutch love referring to as "world-famous in Holland".

I'm playing a gigolo called Lully, in reference to a French baroque composer who died after accidentally skewering his foot with the stick with which he beat time, who later turns into a cowboy called Lully. The gigolo that is, not the baroque composer. You wouldn't have a baroque composer turn into a cowboy would you? That would be simply absurd.

Later I become an undertaker with a striking resemblance to my earlier characters, and I'm still called Lully.

As you can probably guess already the plot is too convoluted and grotesque, albeit in a strangely beautiful way, to explain in depth here, but unsurprisingly in a work conceived by Greenaway, I have to get up to all kinds of dodgy things, some of which I'll explain later. However the most sensational of these is a scene in which a fellow cowboy (called Alcan, after another dead composer) and I have to stuff the heroine inside the carcass of a horse and rape her. We're the bad guys by the way, in case you hadn't guessed.

The casting process for this show was not usual one for my line of work. The first question, before I knew anything of the plot, was "can I ride a horse?" This made a change from "can I sing it?" and I lied that I could. Well, I had ridden a bit and not very well as a child, and the last time I had been on horseback had been on a one-hour trek in the Ashdown Forest. As soon as the horse accelerated to a trot I lost the stirrups and fell off. But I was convinced I had time to learn, and besides, I wasn't going to let something as trifling as that prevent me from getting the job. Oh no. Greenaway needed horsemen because he wanted to film us galloping in full cowboy fashion through the Utah desert, which sounded like a piece of fun too good to miss. The idea was that the film would be projected during the opera and we would dismount, step out of the film onto the stage and sing.

As soon as the lie paid off and I got the job I subscribed to a course of riding lessons, at my own vast expense, and became proficient. Then, as my luck would have it, two weeks before we were due to leave for Utah, we were told it would be too costly to fly us out for the filming and we were replaced on celluloid by two "real" cowboy doubles. Except that they look nothing like us. Still, the effect works well enough.

I was lucky to get away with the equestrian fib as Greenaway is a stickler for detail. A baritone auditioning for the role of Adam (as in the guardian of Eden) in another music-theatre piece was rejected, reputedly, because he is circumcised. Apparently he wasn't cut out for the job.

After lying successfully about my riding abilities I was shown a sort of screenplay, which was to be the basis of the opera that was yet to be written. One stage direction stood out: **"They fuck her inside the horse"**.

That's not a line you often see in opera I must say. The great Da Ponte never penned that one as far as we know. Aficionados of Peter Greenaway's work however might not find this too out-of-the-ordinary.

Extravagant though his work may seem, Peter is not a flamboyant, chatty man. He lives in Amsterdam and I bump into him from time to time in the Albert Heijn supermarket near the Concertgebouw where we'll have Pinteresque conversations:

"Oh hello Chris."

"Hello Peter."

Pause

"What are you buying?"

"Um, I've got a chicken."

Pause

"I've got two avocados."

"Oh yes, so you have."

Pause

"Goodbye then."

"Bye."

That's about as much small talk as we can muster. Of course it is followed by the embarrassing exercise of continuing to browse the shelves without bumping into each other again and having to go through the charade of being vitally interested in the acquisition of, say, a small tin of tomato puree.

With Peter you could tell him that onions are half price today or that the opera house is burning down and the level of response would be the same. He's something of an emotionally closed book. This is not to say that I haven't enjoyed working for him. I have immensely. It's that he doesn't give much away.

We precede rehearsals for the horse opera with a little chat in an office. Just Peter, my fellow bad guy and me. We talk about the rape scene.
Peter kicks off.
"As you know I've never directed an opera before. How far are you willing to go?"
"Excuse me?"
"In the inside-the-horse fucking scene."
"Ah well, I don't think there's any question of, er, actually, well, you know, but there is a danger it could become comic. I have seen singers pretending to have sex on stage and it's so obvious that they're not doing it that it's just funny. I think it should be obscured as much as possible." (And maybe then, I'm thinking, there's no danger I'll have to get my willy out....)
My fellow bad guy, Roger, asks: "How does it work that we actually fuck her inside the horse?" Roger is Dutch you see. He's quite happy to start saying "fuck" from the get-go.
Peter explains that Marie, the soprano, will be inside the disembowelled abdominal area of a (fake) horse and we will climb up the back and take her/them from behind.

At a meeting Peter later had with Marie, the soprano, he asks the same question.
"How far are you willing to go?"
Marie, being ballsy and Australian, tells him: "well, no-one is sticking anything in!"

A few weeks later a session appears on the schedule as a "horse-fucking rehearsal" (not something you'd see printed on the schedule of any other opera house in the world); our first chance to work with the horse carcass. It is an impressive stage prop indeed. Imagine a full-sized horse with axles through its front and rear hooves, on the end of which are large cartwheels. It is a bit like a large Victorian child's hobby horse (an image used later in the show.) A ladder is propped up against its bum. I climb the ladder while Greenaway looks on. I lift the tail and

notice that the mare is – how can I put it? - *anatomically correct.* I could, if I so desired, reach through the horse's vagina into the inside of the cavity where Marie will be stuffed. I remember our earlier meeting. This prop must have been ordered months ago. I imagine the conversation in which the prop-maker tells his wife what he has been doing all day. "Nothing out of the ordinary love, just making an enormous vagina." The only reason I can fathom that the vagina is functional, so to speak, is just in case we had told Greenaway that we were willing to "go the whole hog".

Anyway, here I am, up the ladder while Peter and various stagehands look on, holding the tail in one hand and contemplating the fake horse's vagina and all things connected with its construction, when he says as if he were prodding a piece of cellophane-wrapped haddock in Albert Heijn:

"So Chris, is the ladder the right height for your cock?"

I make some half-hearted thrusting movements with my hips.

"Yup, that seems fine."

"Let me see what it looks like if you pretend to whip Marie with the tail."

I hip-thrust and thrash.

"Yes that looks good. Thank you."

And as I descend the ladder I reflect for a nano-second that when I was young I had ambitions to become a Chartered Accountant.

Here's a brief run-down of the journey I have to make through this "horse opera".

First, of course, I have to get into costume.

Of the cast of five singers and fifty extras only my fellow bad guy, myself and one of the sopranos get to keep our clothes on. Just as well as under my costume I have to wear an elasticised belt around what used to be my waist (it has forgotten the difference between concave and convex) into which is slid a radio-microphone pack. A wire travels from this up my back, is taped to my neck, then up under my wig and down the other side onto my forehead where the miniature microphone is taped and glued. Microphones are an unusual necessity in this piece, which is so loud that not even the great Wagnerian soprano, Birgit Neilsson, would have been able to cut through the heavy and amplified orchestra.

On my wrists I have large elasticised straps, each carrying an oblong nine-volt battery. These aren't here to counter rheumatism. Oh no. From the batteries more wires run to illuminated cufflinks which have to be rethreaded into each shirt of each costume. Next time you put cufflinks on, imagine what it would be like with two ten-inch wires dangling out of the bottom. With all that lot on I look like a booby-trapped oven-ready chicken.

My evening goes like this:
1) Enter with ten-foot long billiard cues (with batteries inside to power little lightbulbs in the tips), avoiding half-naked extras carrying coffins, and point out stains on a hanging bed sheet (sperm, poo, blood....)
2) Simulate wiping fellow bad guy's bottom, rub his left breast and pretend to bonk him doggy-fashion.
3) Rip off soprano's clothes so that she is naked (apart from microphone, cunningly concealed) before heading sharply downstage to avoid collision with three naked women entering downstage right.
4) Wait in wings amongst cow carcasses while baritone bonks soprano, twice, on sofa.
5) Enter as cowboy, hold naked soprano upside down, rip off dead baritone's clothes so that he is now naked, and beat up soprano. Sing very long, very high note (still a tenor at heart, you see).
6) Force soprano onto treadmill at gunpoint, cover her with black ink, then stuff her into horse carcass. Climb ladder, bonk her and whip her with tail. Fire gun.
7) Exit, knackered.
8) Enter as undertaker, sing line "your prick is erect and burning in your mouth" and simulate bonking toy hobbyhorse. Try not to wonder what it must be like to be one of the extras who is not only the fattest man in Amsterdam but also bollock-naked on stage. How does he manage the simple act of peeing? Ignore all dangly bits, male and female that are wiggling past, three feet in front of my face.
9) The End.

o monstrous, o strange

Pierre Audi's on the phone.

"Chris, we need you to do something tonight. One of the dancers was going to do it but he just can't get it right so we thought you could do it instead."

But tonight's the public dress rehearsal. This is a bit late in the day to give me new stuff. What is it anyway? What can't the dancer do? Some twirly thing in a pas-de-deux? No, they'd hardly ask me to do anything like that.

"Can you go to the theatre this afternoon and Martyn (Brabbins, our conductor) will talk you through it."

Oh, it must be a musical thing. Still, as I said, it is the dress tonight. I thought the whole thing was "in the can" so to speak.

I meet up with Martyn.

"Yup, we need to you play a Schubert song by scraping a chair around on the floor."

"Beg pardon?"

"We need to you play a Schubert song, *Ständchen* in fact, by scraping a chair around on the floor."

"Right-o."

"There's a bit in a scene you're not in - yet - where Knaifel (our composer) has put this bit of Schubert scraped by a chair on the floor and the dancer who was supposed to do it can't get it right at all so we thought you could come on and do it."

Martyn shows me the bit in the score and lo and behold there it is, a chair "singing" *Ständchen..* He finds a chair and demonstrates. It sounds exactly like someone scraping a chair around on the floor rather than a piece of refined Lied but there you go. Orders are orders.

"I'll do my best."

Pierre appears.

"So you know what we need you to do now, Chris?"

"Yes, that's fine but how do I get on?"

And Pierre launches into a lengthy description of the scene and how I will have to improvise a whole thing in my role as Sex-Crazed Lecherous Mouse-cum-Circus Master. The opera by the way, if you can call it that, is an adaptation of *Alice in Wonderland.* You didn't know there was a Sex-Crazed Lecherous Mouse-cum-Circus Master in *Alice in Wonderland* did you? Well there is now.

That evening, in the Carré Theatre in Amsterdam, in front of a non-paying public, most of whom are sitting slack-jawed in incredulity at the spectacle unfolding before them, I present my Schubert to the world. The Carré was built as a circus theatre and we're playing the show in the round. A stage manager has sent me on at a rough cue and I'm flouncing all around the enormous stage improvising as if my life depended on it. For want of anything more creative to do, I stick my tongue out a great deal and wag it about. Failing that I use my bottom. These are the sure-fire tools of the improviser-in-panic, especially in the conveying of lewdness. I could be out on the streets busking this stuff and making an absolute packet from gullible tourists.

Martyn flicks me a conductorly cue, I grab a chair from a hapless dancer and scrape to my heart's content. In my head I hear *"Leise flehen meine Lieder durch die Nacht zu dir"* but I severely doubt one single person in the audience, for all my glorious phrasing across the floor of the stage, is hearing that too.

I finish, leer and tongue-waggle a bit more, then run off to change into my next costume. I have to play the King of Hearts atop an enormous moving scaffold. My two big moments are 1) turning the handle of an adding machine for two bars and 2) making my huge powdered wig explode on a very precise cue. I'm not sure anyone really catches either event, not because I'm not doing my damnedest to get noticed; I'm just competing with too much. This show looks like the Cirque du Soleil on crack.

Even the Dutch, easily the most receptive nation in the world to modernism, are baffled. A leering, mooning, Mouse-cum-Circus-Master is small fry to them.

I think the thing that strikes them as odd is the presence of a very large orchestra that barely plays a note. I'm told the bassoonist, one of the country's finest, has seven bars to play all evening. While the highly-trained musicians clutch their silent instruments and count infinite bars of rest, most of the noise that constitutes the music of the piece is coming from the highly-trained singers on stage tapping their chests, blowing noses and scraping chairs instead of actually singing.

When we do sing, it could be in either English, Russian or French. There's one bit I simply can't memorise at all when I'm playing pat-a-cake with a chorus member and the entire company is singing in Russian. I fall back on the OmniVowel, which is a singer's cheat; a non-specific sound which could be "blagh" or perhaps "ulg" depending on pot-luck, and which can

easily get covered by the singers who are conscientious enough to have learned and remembered the real words.

I know I should get this bit right, and no matter how much I study it I seem to get no better, but some bit of me, my can't-be-arsed gene, makes my brain refuse to take it in. There's really no excuse.

After all, in spite of being on stage fannying about for half the opera, and apart from the bit I can't properly remember, I only have one small page of music to sing, if singing it can really be called. The composer wants it to sound as if I'm singing and inhaling at the same time. Try it sometime and I challenge you not to want a short lie-down afterwards.

"Mouse-cum-Circus-Master" is a slightly longer night for me than "First Man In Puff" and "Flute-Player" at the Frankfurt Opera. A nice Romanian lady called Adriana Hölsky has decided that what Jean Genet's impenetrable play *The Screens* really needs is to be turned into an opera of such raging difficulty that not one of its cast members will have a clue what it is about. So she has duly composed it, albeit translated into German, and I find myself spending eight freezing weeks around Christmas rehearsing it to death.

I find Frankfurt a grey and daunting city at the best of times. In the depths of winter there's very little to recommend it. My digs are in a high-rise block of flats in a dreary suburb, the walls covered in chocolate brown wood-effect panels and the bedroom ceiling adorned kinkily with bronzed mirror tiles. Every day I trudge through sludgy snow to catch a train to the city centre, where I change onto another train to go out to a different suburb, there to walk the best part of a mile to a dusty warehouse where we try and come to terms with Genet as reworked by Hölsky.

The only ray of sunshine is that my wife Lucy is on contract in Cologne and sometimes I can take the train up the Rhine to spend Sunday with her. In German houses, and in most others too, the rehearsal schedule is announced on a day-to-day basis, so you don't know until two in the afternoon what you will have to rehearse the next day. Making plans to see loved ones is well-nigh impossible and you have to grab what you can get. At least from Cologne I can phone the Frankfurt Opera company office in the afternoon and if by some miracle I'm not needed the next day I can stay at least another 24 hours before nipping back on the train to Frankfurt.

One Saturday morning it looks as if there's a good chance I won't be needed next until Tuesday. We're supposed to go on stage next week and the warehouse is about to be used for another production. I can't see that there's a rehearsal space anywhere that will accommodate us on Monday. This will give enough time to fly home to England to see my children who I haven't seen for well over a month. I've even mooted this possibility to them and they're excited that we'll be able to spend Sunday together. I'm so confident about this that I even bring a small bag to the rehearsal with some overnight things for the anticipated trip home. I don't care how much it's going to cost. As soon as I have the all-clear from the director I'm taking a train to the airport and the first flight home I can get.

The rehearsal goes well and I saunter up to our director with the phrase "have a nice weekend, see you Tuesday" forming on my lips when the stage manager announces loudly that the entire cast is called for a working notes session on Monday morning in a room in the opera house. Everyone groans. Stunned, I quickly change course and avoid the director before I can mouth "you old bastard" at him. I was so sure, so certain I could get home. Now it's impossible.

I wrap up against the cold, drag my bag from the warehouse back to the station, take the trains back to my hideous digs, summon the strength to ring my children with the disappointing news, put the phone down and burst into tears.

Small wonder then that I find it hard to look kindly on the opera.

My big scene is a sort of courtroom scene. I, The Flute-Player am up before a judge for, well, um, playing the flute. Dramatic stuff eh?

I'm standing next to The Man-Who-Pissed. No prizes for guessing what he's up for.

The guy playing the Judge is a house singer, meaning that he's on salary to Frankfurt Opera, Germany being about the only country left which still employs opera singers on a *fest* basis, whereby the singer, in return for a regular salary, is totally beholden to one company. This baritone has been at Frankfurt for years and has no plans of going anywhere else. It has become for him, like I'm afraid so many other contract singers, a case of getting through the gig with the least-possible effort. If he can make it another few years he will become un-sackable under German law and will have achieved the rare thing of being a

fully-employed singer from the beginning to the very end of his career.

On this basis, our Judge has made it well-known that he thinks this opera is a piece of utter crap and is pretty indifferent as to whether or not he gets it right. That's all very well, but the rest of us rely on the Judge for crucial musical cues and if he's getting it all wrong then so are we. The scene all too frequently breaks down in rehearsal. At least he mutters "*entshuldigung*" to his colleagues when he cocks it up. It's difficult to say how it looks from the audience but it feels up on stage that we're spending the entire scene staring fixedly at the conductor for fear of getting utterly lost.

In my final scene I am one of a trio of what can best be described as zombies. This is supposed to be a coup-de-theatre: three different utterly unintelligible scenes playing simultaneously. My fellow zombies are an English tenor, Phil, who once taught me the piano at school so I've known him a very long time, and a very distinguished German house bass on the verge of retirement. The bass thought he might bow out of his career with a final Baron Ochs, a role for which he has an enormous reputation throughout Germany, or another of the classic bass roles like Osmin or Bartolo. But no, it looks like his swansong will be as Zombie 3. As often as not, we plod on stage dressed in black padded ice-hockey suits (or so they seem), our limbs akimbo, our faces in an appropriate rictus and fail spectacularly not to giggle. The distinguished bass is the worst culprit. He peppers the arbitrary zombie noises we are required to make with resonant, fearless and beautifully-produced exclamations of "*Scheisse!*". Phil and I meanwhile have to zombify hastily upstage for fear of revealing our chortles to the stupefied audience.

help!

Tuscany. 1983

I'm playing table-tennis with Sir Georg Solti in his garage.

It's not often I get to say that.

I've been singing in a festival in Batignano where an English designer, Adam Pollock, has bought the half-ruined convent and made it his home. Every summer he puts on a few operas and invites British singers and musicians to perform, for no fee I might add; just their travel, a roof over their head and three communal meals a day. There's no hot water and no electricity in most of the convent. You sleep on a mattress on the floor.

Solti has a villa by the sea not far away and comes to see the odd show. He has rashly invited "the cast" over for a day at his house. I think he expected about eight people to turn up but someone's laid on transport and there are nearer thirty of us.

Before lunch we all pad about his home trying to feel at ease. Solti leads a group down to the beach and announces in a tone that smacks of being a command that "ze girls are more than welcome to take off zeir bikini tops!" When he tires of watching that he decides he wants to play table-tennis. So I find myself partnered with Nicholas Kraemer, who's conducting our show, facing Solti and Graeme Jenkins - who's also a conductor destined for big things. So, that's three conductors and one tenor. What a combination.

We play and pretty soon Kraemer and I are wiping the floor with Solti/Jenkins. Solti keeps score. His bat technique is not so far-removed from his baton technique - clipped, jerky swipes, but they're doing him no good. You would have thought he'd be an absolute natural at this, and he seems to think that too, but things aren't going his way.

And then I notice. He's cheating.

They're 14-8 down and they win a point.

"Okay, zat is 14-10"

Nicholas and I exchange glances and know we shouldn't say anything.

We win a point.

"Now it is 15-11 I zink"

Next point to Solti/Jenkins

"15-13"

Nicholas and I finally take the game 21-15. Solti's frustration at losing is more than he can handle. We're ready to play another

game but he plops his bat onto the table with a sharp thump and says "Okay, zat is enough of zat, now ve do zumzink else".
We have lunch and Solti retires indoors to nap before studying *The Ring*, which he's conducting soon. We hang around for another hour or so then travel back to the convent ruins.

What is it about conductors that makes them want to conduct?
I'm sure most of us have spent time we'd rather forget, in front of a mirror, waving a pencil around in the Toscanini equivalent of playing air-guitar. But what really motivates someone to go the step further and decide they'd like to do it for real? It must be a strange mixture of chemicals that flushes through the veins of someone to make them think: "*what the eighty-odd highly trained and expert musicians that constitute a professional orchestra really need in their lives is ME waving my arms around in front of them and generally telling them what to do!*"
As Norman Lebrecht observed, it is a bizarre and baffling phenomenon that, during a concert or opera, the one person in the performance who is almost certain to be paid more than anyone else is also the one person not actually making any sound.
I have come to the conclusion that of all the so-called conductors in the world only about 10% actually know what they are on about. I have worked with immensely famous conductors who can't beat their way out of a paper bag. They also can't tell if someone is playing or singing wrong notes. All they have which qualifies them for the highly-paid job are enormous egos. I have turned up with my role memorised at the start of rehearsals to encounter conductors who haven't even cracked open the score, who don't know how it goes and who basically rely on the singers to teach it to them. And then they have the balls to start bossing us around.
Italy in particular still believes in the cult of the conductor. They still seem to labour under the illusion that conductors are endowed with mysterious powers which only the presence of a full orchestra to be shouted and screamed at can begin to reveal. Italian opera performance seems to based around the concept that singers are too stupid to do anything but be controlled by a prompter hidden in a little box in front of the stage. As long as the prompter can keep this unruly mob under control, the Maestro (which must be *the* most pompous title in creation) can dish up magic in the orchestra pit and not bother himself with the

minutiae of whether or not the singers are actually singing in the right place. No no, such tasks are way beneath the silent genius. In fact, in an Italian opera performance you actually aren't hearing one performance, you're hearing two at the same time; one on stage, led by the prompter, and one in the pit, led by the dictator, er sorry, conductor. The only link between the two is a small television camera so that, if he's lucky, the prompter can follow the conductor's so-called beat.

I suppose it's a phenomenon of human existence not limited exclusively to music that someone who appears to contribute the least is at the top of the pile. Do car-workers at Ford resent a CEO who doesn't know a carburettor from a crankshaft, and who couldn't actually *make* a car? I would hope so.

The thing that is odd in my line of work is how the two most powerful figures in the opera-performance hierarchy these days - by which I mean the conductor and the director – have mutated from being the lowliest of the mob to the highliest. Conductors used to be people who just stood at the side of the band and literally beat time with a pole. They were metronomes incarnate. I suppose they did tend to be composers too, but even so, to promote to boss the only person in the room who cannot demonstrate his talent because he makes no sound whatsoever seems to be the most suspicious of selection processes.

As for directors, more on them later.

Under the spell of the cult of the conductor, Italian baton-bandits are spared the indignity of coming to staging rehearsals that are with a humble piano. No, these are beneath them. How can they sully their divine perceptions of The Music by enduring the tinkle-tinkle of an upright piano? Besides, if they had to be there all the time how could they possibly fill their diary with other engagements? No, a conductor works like this:

1. Turn up after two weeks, when much of the staging rehearsal has been finished. Be generally condescending. Suck teeth at aspects of production even though they are none of your business.
2. Demand a music rehearsal with the principal singers. Flex artistic muscles and sack one of the aforementioned, thus causing a ripple of panic throughout the opera house. Never, of course, sack one's own untalented girlfriend if she's in the cast. If management hints it is

unhappy with said girlfriend then sack someone else so that at least *someone* gets sacked. (I'm not making this up. I have seen this happen.)

3. Bugger off to do other gigs and start learning score of this one. Reappear in time to rehearse (i.e. shout at) orchestra.
4. See complete staging for first time ever at a stage and orchestra rehearsal. Demand loudly that staging is changed especially if it will make girlfriend look better.
5. Generally be a pain in the arse and if necessary demand another rehearsal with knackered singers so that, now you know the score, you can change everything they have been doing while you have been absent.
6. Consider threatening to walk out if it will make you look more artistically highly-charged.
7. When the show finally opens, ditch untalented girlfriend and pursue different singer (male or female). Between performances fly to different city to start rehearsals for next show, as yet unlearned, and repeat above process.

There are exceptions, of course, and shining ones too. When I was still at the Royal College of Music I got tickets to a dress rehearsal at Covent Garden of Verdi's *Otello.* I used to go to a lot of dress rehearsals there but this one hadn't turned up on the usual schedule. The opera house had planned to keep it a closed rehearsal and then, a couple of days before, had opened it up to a lucky few.

I didn't know *Otello.* Not a note. I didn't even know the play. Domingo was to be singing so I thought "oh well, might as well troll along and give it a look-see. If I'm bored I can always leave at the break." I'd heard of Margaret Price, singing Desdemona, and a few of the others. The conductor's name was very familiar but I'd never heard him in action. Carlos Kleiber. "Probably just another podium diva" I thought.

The small audience settled down in the amphitheatre. A greying chap loped into the pit, lifted his baton and BOOM, I was suddenly engulfed in what sounded like the loudest storm in God's creation.

I was a mess. My skin was crawling, my hair on end. WOW! WHAT WAS THAT?!! BLOODY HELL!! GOD THIS IS GOOD!!!!

And so the rehearsal went on. I was mesmerised. I'd never heard anything like it. It was, and still is, one of the most exciting things I have ever witnessed in a theatre.

A week later I queued from 6 a.m. to get a seat back in the Gods. The performance was as electric as the rehearsal had been.

A few months later there was a revival, the last of this creaky old production, with a different cast and a different conductor. I went to a show. I sat in anticipation of the bolt of lightening that would surely be the opening few bars, and when it started I was overwhelmed not with excitement but with disappointment.

"Oh. Well, that was the same music, but it sure as hell didn't hit me in the same way. That wasn't a storm at the beginning. More of a stiff breeze."

And, catching up with everyone else on the opera planet at last, I came to the conclusion that this Kleiber bloke who'd been at the helm the first couple of times must be a bit special.

Five years later my agent calls.

"The Garden wants to hear you sing some Verdi."

"Really, wow, why?"

"A new *Otello*. They're thinking about you for Roderigo."

"Gosh."

"Yup, it should be quite a thing. Domingo, Ricciarelli. Elijah Moshinsky directing and, oh yes, Carlos Kleiber conducting - - - - - - Hello Chris, are you there?"

"Yes, yes, fantastic. Right, wow, I better polish up my Macduff aria."

"Yes, you better."

So a couple of weeks later I'm on stage at Covent Garden doing my best to be butch and Verdian. I really want to be in this. This will be enormous. What a thing to be a part of.

I've done a Victorian evening - parlour songs, scenes from Dickens and duets with Andrew Shore - in Devizes the night before and I seem to be struggling with some sort of throat infection. I warn the bodies sitting around the stalls that I'm not well and they are, as usual, immensely polite and sympathetic. One thing you can never fault the Royal Opera on in this golden age, their manners.

I wack through the aria without making a total fool of myself but I think I'm pretty ropey and I'll be lucky to get it.

Back at home that afternoon my agent rings again.
"Congratulations, you're hired."

A year or so later and it's our own dress rehearsal of *Otello*. It's a very cold January day outside with snow on its way but inside the theatre it's blazing with hot Italian music. The storm was awesome. I can barely breathe with excitement. I'm giddy with it.
Iago and I have our recitative. Well, I say *our*, but he's doing most of the singing while I pop in the odd line. True to his word, Kleiber is following like a hawk, this enormous, generous presence in the pit coaxing the best out of us. He's told the orchestra that he's too old and slow to follow us. They know how it goes. Much better if they follow the singers in the recit and he'll do his best to keep up. The orchestra loves him for this. I mean *really* loves him. They worship him, which is why they're playing so bloody well.
At the end of the drinking scene, the fight between Cassio and Montano breaks out and I hurtle off stage to fetch help. As I belt offstage Domingo (whom Ron, the make-up chief, calls Daisy to his face, as in "Shut the fuck up Daisy and get on the fucking stage!") and Katia Ricciarelli are waiting to make their entrance. I'm so fired up with the miracle that's happening on stage I grin inanely at them and give them a double thumbs-up. They look at me as if I'm a bit mad.
Otello is a sensation. Tickets are gold-dust. The rich and famous are begging the company manager to be found tickets. I spend chunks of the show in the wings simply watching Kleiber on the TV monitors. He's a show in himself. And all the time there's this stunning playing and singing been drawn out by him.
At the first night party in the Crush Bar, Domingo finally appears almost two hours after curtain down and he's still in costume and make-up. He's been coping with a staggering number of visitors and hasn't had a chance to clean up.
The day after the last show my wife is due to have our first child. I knock on Domingo's door in the first interval to ask him to sign my programme as a pre-birth memento. I hesitate to ask as I can see an enormous pile of similar programmes that he is systematically working through. They're from every member of the children's choir. What a gent.
"Chreees. Come in, come in."
I make my little request.
"Of course, of course. Good luck eh?"

And he writes *Happy Landings!* above his name.

Two years later and we revive the show with the same leading team.

Kleiber wants a sing-through of all the ensemble scenes, with piano, before we start rehearsals. We gather, nervously, in the Chorus Rehearsal Room, the principals (except Otello and Desdemona) at the front and the chorus in their usual seats. The place is stuffed.

Kleiber comes in, sits at a table with his score, all smiles and hellos, and takes out a small electric metronome, flicks a switch, looks at it for a few moments and then puts it down. Puzzled looks are quietly exchanged among the company but nothing is said. We sing the opening.

Next bit. Again the routine with the metronome. We do it again and again Kleiber checks his metronome.

He can sense that the room thinks that this is, how shall we say, unlike him.

"I can see you are wondering why I keep looking at zis metronome. My daughter gave it to me recently and, you know, I discover zat all zese years I've been conducting everything at ze wrong speed."

The whole room giggles.

"Ve conductors should use zees more you know and actually look at ze tempo ze composer asked for, but of course, you know, ve conductors, ve always know best!"

As if we didn't adore him enough, now we all want to have his babies.

"Zere is a bit coming up, where Cassio says he is going to crush Montano's head like a melon; zis is such a horrible image I would like it if some of ze ladies in ze chorus could gasp audibly. I'll tell you why. I heard zis on a recording recently and I thought it was so good zat if I did it everybody would think zat dis was my idea!"

He's brought the house down. Not only does everyone in the room think he's the best conductor on the planet but he's being self-deprecating too. It's as if he thinks the whole adulation of conductors is absurd and he's making it his life's work to tell everyone.

A couple of weeks later, I'm waiting on stage for the start of our first stage and orchestra rehearsal. The curtain is down and they're fixing a few things on the set. The orchestra is tuning and

warming up in the pit. Suddenly I notice Kleiber standing next to me. Blimey.

"Good morning!" I blurt.

"Ah, good morning!"

He looks a little uneasy.

"How are you today?" I ask.

"Nervous, very nervous. I alvays get so nervous before ze first orchestra rehearsal!"

(I'm thinking *What? You? But you're the top dog!*)

"Gosh really! I had no idea. Me too, haha!"

I'm desperately trying to think of something to say and come out with:

"Of course this time last year I saw you conducting the New Year's concert from Vienna on the television."

"Oh you saw zat? Yes, you know, za problem wiz all zat Strauss is it all sounds za same. I had no idea which piece was which. Zo I put down a downbeat, waited for it to start and then I thought "oh yes, it's zis one, off ve go!""

This is dynamite. Here I am, standing on the stage of the Royal Opera House, Covent Garden and one of the true geniuses of the baton in the world, in history, is telling me that he bluffs for a living. Would that some of his less-talented colleagues could do the same.

The stage manager whisks him down to the pit and we start the rehearsal.

Just before the last performance of the run, Domingo falls ill and word is that Ricciarelli is not feeling too hot either. The replacement Otello they find is Jeff Lawton, who has sung the role for Welsh National Opera, but whom Kleiber doesn't know. The company manager rings the rest of the principals and tells us in excited tones that Kleiber wants a quick rehearsal with us all so that he can decide whether or not he's willing to proceed with the performance. We gather in a tiny rehearsal space in Floral Street. No Ricciarelli. She's still deciding whether she's well enough. Iago is there - Justino Diaz - as well as the rest of the principals.

Kleiber turns to Justino.

"So Justino, you're not cancelling then?"

"No, I can't afford to!"

"Yeah", replies Kleiber, "me neither!"

He sends most of us away without any rehearsal and the show goes ahead with Jeff in the title role.

thou art changed

So here I am, still in Madrid rehearsing *A Midsummer Night's Dream* and still with the feeling that I'm here much, much too early.

It's now Thursday and I've been here since Saturday. All I've done since Monday is a couple of hours of sing-throughs with our Romanian conductor who takes everything so fast that it will seem more like a midsummer afternoon's forty winks than a night of dream-filled sleep. Still, not my place to say anything. I'm just a singer and a character singer at that so what could I possibly know about music and how it should go? Given the collective experience of our cast, the conductor may as well be trying to teach the sucking of eggs to a large bunch of whiskered grandmas but we're so well-behaved that we pretend to hang upon his every word.

Today, Thursday, is the day we're supposed to start staging the opera with the director. He's an Italian, hugely respected in Mediterranean Europe, who does his own designs. That in fact was his first calling, design, so I'll be intrigued to see how he works as a director.

At five o'clock the Rustics pile into the vast rehearsal room and there he is, an elderly gnome dressed entirely in shades of burnt umber, from head to toe. In alarmingly broken English for someone who's about to direct a Shakespearian comedy laden with linguistic nuances, he croaks that he is starting a cold and we won't be able to rehearse today. He just wanted to take a look at us. So we stand in front of him and he looks us up and down, one after the other, muttering to himself.

My turn.

"Flute, ooo ees Flute?" asks the Umber Gnome.

"That's me."

"Ah yess, I see. 'Ave you done Flute before?"

"Ooooooh yes, many times."

"Wheeech productions 'ave you done?"

I reel them off.

"Good, good." He seems relieved by my experience in the role. And yet I've told myself I'm not just going to wheel out the Flute I've been doing for the last 23 years. I'm going to be a blank canvas and let our director work his magic. I'm going to pretend

to myself at least that this is my very first time. I am a Flute virgin all over again.

"Good. I am sorry for zees cold, zat I am sick. So, tomorrow you all 'ave a free day and we work on your scenes Saturday afternoon."

"Ah", I think "so that will have made it a full week later that I could have got here and nothing serious would have been missed." I had to turn down some *Messiahs* I had been asked to do this weekend - one in Lucerne and another in Bristol - because the Teatro Real told me it was totally unthinkable that they could spare me. Huh.

We bundle off to a bar and drink several beers.

Saturday comes and we all meet again, eager to kick off the process at last. There's no discussion about our characters, or even where and when this is being set. Zilch. Not even a costume design to look at. The BIG IDEA for the Rustics, the motor that will quite literally drive our scenes, is a small electric truck that sounds like a converted milk float, with a trailer at its rear. Quince will drive the truck on with us in the trailer, we'll play our first scene, and then we'll drive off.

"OK, let me see da scene," says the Umber Gnome.

Oh, ok, no direction at all then. Improv time. So much for me being a blank canvas. Still, I'll play it low key for the moment.

We drive on, we improvise something with no help whatsoever, we get to the end of the scene and we drive off.

"Good. Let me see it again, and zees time can you drive off sooner?"

No notes or observations about what any of us did then? No hints at some bits being brought into focus? No? So you're just going to let six old hams like us fart about uncontrolled for five minutes? Apparently so.

We do it again, much in the same vein as we did it the first time. The Umber Gnome frets about getting the truck into the wings but says nothing to us at all. I can see him muttering to himself in Italian as we run the scene but he's keeping that very much to himself. Oh hang on, he seems to be miming something to himself as if that might be what he'd like to see one of us do. But who? And why doesn't he just tell us rather than keep it all to himself? This is most bizarre. It's like rehearsing as if there isn't a director at all.

We work through our four scenes. In each scene we drive on in the truck, do the scene and drive off. That's the one Big Idea. The whole thing is set in the space of an hour.

How on earth are we going to fill the next weeks of rehearsal if this is all we ever do?

Just before we all head home for a three day Christmas break there is a run-through of the entire opera in the rehearsal room. The press department has organised a photographer to be present to take "in rehearsal" shots for both the programme and the usual round of pre-opening press features. The camera is never pointed at us though. Oh no. With a photographer in the room, the Umber Gnome is occasionally animated to the point that he actually goes up and speaks to some of the singers. When he is having these brief flutters of life the room echoes to the *chak-chak* of the camera shutter. The world outside this rehearsal room will think the Umber Gnome is the second Billy Wilder, a dynamic director at work, using his energy and insight to tease the very best from his performers. A fat lot they know.

The rehearsals resume after Christmas and continue on stage for another two weeks. The Umber Gnome never gives me one word of direction.

I discover a good trick. At each rehearsal I add one of the subtle nuances, otherwise known as well-worn, trusted old gags, that I've been using for years in this role. I could add them all at once but no, the trick is to let them out in a drip-feed. This goes down a treat. I can hear the Umber Gnome chortling at what he believes to be a new visual joke I've popped in.

The company manager comes up to me and says: "Chris, you are so brilliant and inventive! You add something new every day!"

Little does she know that I've just been holding back and that I'm now trying to bolster up what passes for a production with every trick in the book. I'm manning the lifeboats before the show goes down with all hands. Oh well, if it's fooling them it will probably fool most of the audience too. All except the handful of opera nuts that is who might possibly have seen me in this role somewhere else.

Directors used to be called stage-managers. They advised you where to come on and that was it, so perhaps the Umber Gnome is merely Old School. It's just that the Director has become as

important, if not more important, in the process of mounting opera, of *selling* opera than almost anyone else.

Look at a playbill of any 19th century opera and you would have no clue as to who actually directed it. Now, the Director has risen from the rank of glorified scene-shifter to demigod of taste, even to the point that the poor old composer often takes lower billing. Hasn't it all gone a bit barmy? At which point in history did all the expensively-trained singers and musicians at the opera get together and say "Hey, let's put the guy with the clipboard in charge!"? I'm curious to know.

Opera directors fall broadly into three schools.

First there's the Traditionalist or Director Who Just Does Opera. He's usually someone who worked his way up from the bottom, starting as a stage manager or sub-assistant director. He'll know how to handle a big chorus, considered one of the big tests of any opera director's craft and he'll know how to handle divas. The chances are that his productions will be safe rather than startling. He won't use any funny rehearsal techniques. He may even have everyone's moves written down long before anyone has stepped into a rehearsal room, which doesn't make for an interesting rehearsal process but it does make for a safe one. And a short one too. The Director Who Just Does Opera can bung on a *Figaro* faster than you can whistle *Voi Che Sapete*. It just won't set the world alight.

Second there's the Designer Director. This is usually someone who has spent many years doing designs for other directors and then fancies having a crack at the old directing lark himself. "How hard can it be? If that idiot I did *Rosenkavalier* with can do it... besides everyone raved about it being *his* show and *his* concept when it would have been nothing without my designs." The trouble with the Designer Director is that he tends to think that singers are glorified puppets. If you just stand them in the right place in the lovely set and costumes then it will be wonderful. Some Designer Directors have become cult figures but I'm not convinced that this isn't more out of a love of the *cool* than an understanding of the complexities of music theatre. Stick a copy of *Vogue* in front of their fans with some Philip Glass pounding out of their iPods and they'd be just as happy.

Third there's the Film Or Theatre Director Who Thinks He Or She Can Do Opera. Some of them can, and some of them do it brilliantly. Many, however, are dreadful. Not only that but they're patronising to boot. They arrive with the unshakeable prejudice

that all opera singers are stick-in-the-mud numbskulls who insist on doing this dreadful *singing* that the Film Or Theatre Director Who Thinks He Or She Can Do Opera can't bear. The singing is alright if it's done in Musicals because, chances are, the Film Or Theatre Director Who Thinks He Or She Can Do Opera has already done one of those, and has earned a squillion from the takings, thus freeing him/her up to whatever he/she wants, which includes bringing their genius to bear on the stuffy old world of opera. The conceit that all singers are crap actors is matched by another conceit, that care of the music or the composer's intentions is simply laughable and that anyone who dares to suggest that the music might be important is either a member of The Music Police or a philistine.

The other stock-in-trade of the Film Or Theatre Director Who Thinks He Or She Can Do Opera is the broadsheet newspaper piece just before the production opens in which he/she puts it about that he/she was anxious about working with singers, that he/she has brought the singers enlightenment in the ways of the theatre but, oo er, come the first night who knows if they won't suddenly change back into footlight-hugging, bombastic divas because, titter titter, they are just *opera singers* after all. "It's back to straight theatre after this for me and the more balanced egos of *real* actors."

Hmmm.

When the Madrid Dream opens the papers are full of the Umber Gnome's directorial genius. And pictures of him being dynamic and director-ish. Thank goodness he was able to help us so much. I don't know what we would possibly have done without him.

thou art translated

Turin

The strings in the orchestra are *glissando*-ing up and down, playing the familiar opening bars of *A Midsummer Night's Dream* and I'm having a look from the wings of the Teatro Reggio. The stage is almost bare save for a large backcloth on which is painted a large Venetian *palazzo* hotel.

Two male dancers dressed as sailors are picking up a transvestite prostitute. I'm not making this up. Really, two male dancers dressed as sailors are picking up a transvestite prostitute.

As for me, I'm in my costume, a pair of overalls, trying to remember what the rationale was for this peculiar spectacle. I vaguely remember something about the whole opera now being set in a hotel and the Rustics being hotel maintenance staff. Fair enough. But why Venice? Ah that was something about Britten going there before he died, but what's with the sailors and the tranny? Is it a subtle dig at *Death in Venice?* I'm not sure we were really ever told.

And then there's the big tree in Act 3 that turns into a bed, presumably in the middle of Theseus' bedroom. Again we've not been enlightened.

The director, an Argentinean who runs a cabaret theatre in Paris, which makes him first choice in my book to direct a Shakespearian comedy, threatened to walk out the other day. No, he did walk out, when a couple of singers joked around in the tree bed at the end of a stage rehearsal. Suddenly, from the hitherto silent stalls, there was this explosion of yelling and there he was shouting "How dare you?! How dare you pour zis sheeeet on my bootiful production?".

Someone from among us, the only one not standing open-mouthed in astonishment, appealed to him that it was just a joke. But he replied "I 'ave never in my 'ole life been so bad insulted" (further reinforcing my opinion that Shakespearian syntax might be a tad beyond him) and sweeping his expensive bright yellow scarf around his neck in a move that I later copied for the play scene, he marched mincingly from the stalls. I thought people only did that sort of thing in movies. As the swing doors flip-flopped shut behind him, most of us thought *oh goody, perhaps they'll cancel this godawful show and pay us off* while, of course,

feigning noises of concern. No-one ran after him. The American conductor rehearsed a few bits and then we disbanded for the night.

Next day the Argentinean was back, nothing more said. The rumour was that he had made it as far as the airport. Where exactly he would have gone at that time of day is a mystery but for the rest of us it was an opportunity missed.

Much more interesting to me than this terrible show is the lavatory paper ration.

My first day here in the Teatro Reggio I was given a dressing-room key, which in itself is unusual on day one, and, in what could be construed as some sort of bizarre award presentation, six rolls of bog paper.

Well that's very kind. I'll take these back to my digs. And so I did, resisting the temptation to thank my family, my agent and everyone who had helped to make this fabulous award possible.

It was only after a couple of weeks, during which I hadn't had to use the facilities in the theatre, that I made the shocking discovery (and believe me, it was a shock when it happened) that the principals' lavatories had no paper unless you took in your own. Ah. I can only assume that there had been a spate of bog roll theft and that this was their solution. So I had to bring a couple of rolls back to see me through the run, so to speak.

It reminded me of another big Italian opera house. Once he has got to know you, the stage door man will produce a briefcase full of watches and ask "you wanna buy Rolex? Ees no fake. Ees real stolen Rolex!"

Rome Opera also decides to mount *A Midsummer Night's Dream.* Initially the plan is to import a tried and trusted production but then they discover it won't work technically in the theatre. They blithely cancel it a few months beforehand. This is not unusual in Italy and what is also not unusual is rather than stick to the terms of the contract they say either a) that they hope they'll "offer you something else in the near future", which is a fat lot of good when it comes to paying next month's bills, or b) "get lost and if you want your fee you'll have to go through the Italian courts", which isn't a useful option. Since the Rome Opera, which tends to concentrate on standard Italian repertoire, is hardly likely to have roles to offer a cast of *A Midsummer Night's Dream* in the near future we look pretty-well screwed. But, unusually, the cast's agents team together and tell the Opera

that if they don't compensate us they will sue, and faced with a large legal bill the Opera decides to bung on a cheap new production of its own.

And boy is it cheap.

To costume the show we're taken out in groups to the shops. The show will be in modern dress so the Rustics get taken to a sort of flea market where we get to pick cheap and nasty clothes in accordance with our lower social status. The Lovers get blazers and summer dresses from an upmarket couturier.

For the play scene the idea, which is a good one, is that we have purloined various household items to use as costumes and props. So, for my Thisbe wig I'll have a string mop head perched on my head, my dress will be a sheet nicked off the washing line, tied around my waist with the washing line itself. The Lion's costume is made from bathroom carpet and so on.

The budget runs to having almost no scenery.

We are asked to modernise our trades, and as Shakespeare describes Flute as a bellows mender I decide to update him to be a vacuum cleaner repair man. So, naturally, I bring an old hoover on stage for the first scene and prod it with a screwdriver while we do the scene.

For the play, we have a free hand. This, I am realising, is quite the norm in Italy. Just send the Rustics out, let them ham it up and that'll pretty-well do. It's a pity because it can too easily descend into a terrible free-for-all. We do rehearsal after rehearsal and never get a note nor any direction at all. Nothing. It's difficult to tell whether we should give more or do less. No-one is going to police or advise. It's all down to us.

On the day of the dress rehearsal I decide that my Thisbe needs big boobs. Since nobody is going to argue whether or not this is a good idea, I might as well just go ahead and do it. I'm thinking like Flute, albeit a chauvinistic Italian Flute.

What do ladies have?

Breasts.

How do I make breasts, big ones for preference?

Balloons.

So I go shopping. Buying balloons is not as easy as you might think in downtown Rome but eventually I find some.

That night, as we change behind our little on-stage curtain, I blow up my balloons and arrange them under my sheet dress. They work well, providing lots of comic opportunities. When I stab myself with the wooden dagger I can flinch at the prospect

of bursting my enormous breasts and lightly tap the knife on my chest before collapsing extravagantly. When I stand up again at the end of the play, one boob has moved down to my waist and the other is trying to escape from the side of my dress, providing the opportunity for some pantomime boob rearrangement. This is all good stuff.

The director says nothing so I assume he's happy with my invention or has washed his hands of the whole enterprise and simply doesn't care any more.

Come the fourth performance, the director has long gone and no-one at all is monitoring the undisciplined mess we are calling a show. I put my balloon boobs in as usual. Come my suicide I wincingly tap them with the wooden dagger so they don't pop, I sing my last "Adieu" and then collapse straight onto my front with a bit more energy than I usually muster. The balloons must be in exactly the right position because as I hit the floor they explode with two enormous bangs.

Players in the orchestra pit spin their heads to see what's up, the conductor takes his head out of the score. Theseus, who is supposed to sing the line "Moonshine and Lion are left to bury the dead" corpses hopelessly and can barely splutter a note. Lysander's next phrase doesn't happen at all. He's just wheezing with laughter. Bottom, under me, is shaking uncontrollably. The conductor is not getting the joke and is waving frantically. The laughter spreads like a virus. It's as if the full absurdity of this production has suddenly been unleashed and is exploding as gloriously as the balloon boobs.

Flute's Third Scene

The Rustics have been searching for Bottom, and are despondent, worried that without him the play will be off and they won't win a pension. Bottom appears, transformed back from an ass to his usual self. He has news too; their play has been chosen to be performed to the Duke. They excitedly discuss what they need to do to prepare for their "sweet comedy".

sixpence a day

A few years ago a baritone friend of mine was under contract to Scottish Opera and was living in Glasgow. A true Geordie, he's an ardent fan of Newcastle United and travels wherever he can to catch their matches. One Saturday he found himself in the middle of a pre-match pub brawl. The police arrived and lined up everyone on the pavement outside. One bobby, assigned the task of taking down all their details, came down the line with his clipboard. Stopping at my friend he said:
"Name?"
My friend gave his name.
"Address?"
He gave his address in Glasgow.
"You're a long way from home."
"I'm a keen supporter, me, ya ner, never miss a game."
"Occupation?"
"Opera Singer."
A brief pause. The policeman's biro hovered above the paper, his eyes still down.
"Try again. Occupation?"
"Opera Singer."
The policeman looked up and pointed the pen menacingly.
"Look sunshine, I'll give you one more chance or you're in the van. Occupation?"
"Roofing Contractor."
"That's better. Next!"

If, like the policeman in that true story, you imagine that all opera singers are wealthy camelhair coated, Rolex-wearing types who lead a plush existence in five-star hotels and chauffer-driven limos, then you already have most of the qualifications needed to become the landlord of a rented apartment in a foreign city. Say the words "opera singer" to anyone with whom you are going to perform a financial transaction and you can virtually hear the cash-register ker-chink ringing inside their heads, or see their eyes spin like the wheels on a one-armed bandit stopping on a line of cherries.
How it usually works is this: the opera house for which you are going to work will have a list of apartments available to rent for a couple of months - these are usually owned by people with

connections to the theatre – and for which you personally will have to fork out quite incredible sums of money. You can find yourself in an apartment that a "normal" tenant would rent for £200 a month, albeit on a longer let, but for which you pay £1500. How do they get away with it? First, by keeping the price slightly lower than the cost of a hotel. Second, by knowing that it's a Hobson's choice. Most of the time you have no idea what the going rate is until you are well and truly committed.

Furthermore, you usually arrive at night-time, tired and laden with luggage, too grateful to have stopped travelling to exercise your best judgement on the comfort-to-cost ratio when surveying your new home, and it is usually not until 48 hours later that you start to realise that you have been well and truly ripped off. When you search in vain for a halfway decent kitchen knife or cheese-grater you realise that once again you've been duped; how naïve of you to expect these things when you're handing over such vast wads of cash! Oh yes, and the owners of these places always want cash alright, strictly hush-hush and well before you've even smelled a pay cheque for the job in hand.

I once arrived in Lausanne on a cold November night and checked into what was a very comfy little apartment for which I was paying enough to put the entire Family Robinson through yodelling school. The only snag was that the phone didn't seem to work and I couldn't ring home to say I was safe and sound, nor could I connect my laptop so that I could e-mail. The ritual of getting satisfactorily connected up gives me perverse pleasure, and to prove it I have a small sack positively bulging with phone gizmos, adapters and cables, of which I am absurdly proud. I managed to contact the landlord the next day.

"Is everything alright? It's a lovely apartment. Very desirable."

Yes, fine, only I can't get the phone to work.

"Phone?! No it is not connected. You want a phone??! Haven't you got a cellphone?"

Well yes of course but the cost of international calls is prohibitive.

"Oh (thinking: but you are surely a camel-hair coated Rolex wearer who doesn't give a toss about the cost of a phone-call), *well in that case I'm going to have to rip you off even more and charge you another £100 to have a phone connected."* (Or words to that effect.)

Blimey (or words to that effect).

In the end, outraged by such tactics, I decided to manage without a landline and opted for a Swiss SIM card for my British mobile (to make incoming calls cheaper) and spent long hours in freezing phone booths talking to my children via cheap phone cards.

The same landlord, when it was time for me to leave ripped me off again.

"Have you arranged for the apartment to be cleaned after you leave?"

"I beg your pardon? I am very clean and I'll hoover, strip the bed etc..."

"But when you leave a hotel someone cleans the room for the next person and I have someone arriving very soon"

"But surely the person who is leaving the hotel doesn't pay a surcharge to have the room they are vacating cleaned?"

"No no, this is not correct. I am sorry but you will have to pay for a cleaning service!"..... and I ended up, fool that I am, coughing up the Swiss franc equivalent of £85. For that price I hope they polished the floors with wax rendered from the rarest Edelweiss. But I got my revenge by not stripping the bed and leaving the place just a little bit grubby. I also didn't own up to the fact that a knob on the washing machine had broken off in my (ahem) vice-like grip and I'd bodged it back on really rather better than was necessary with some glue and a chunk of a chopstick. That showed him.

o most courageous day!

Genoa

The door handle has just come off in my hand.
Oh perfect.
It's so silly I could almost giggle.
There are two thousand or so in the audience and here I am,
holding a door handle in my sweaty palm. If this were a comedy
it would be a good gag, but it isn't. Far from it.
I jiggle it back onto the spindle and, this time, gently turn the
handle and push open the door. Inside what the audience thinks
is the bathroom there should be some dressers ready to change
me into a white suit, but all I can see is a big hairy stage-hand
picking his teeth.
"Costume? Er, *sartoria*?" I hiss frantically.
The big hairy stage-hand shrugs.
Oh shit.
I thought I had sorted this out. I thought I had made it clear,
albeit in my dodgy Italian that I was going to change into the
white suit now but, no, they misunderstood. Now, after the next
short scene, I'm going to have to do the quick change I so
dreaded - about forty seconds if I'm lucky to change from one
suit to another - and then come back on stage and sing one of
the trickiest bits of the opera.

It might have been alright if I'd had just one rehearsal but I've
never set foot on the set before. All I've done is watch rehearsal
after rehearsal from the stalls. I haven't had any rehearsal with
the conductor either. And this is no small role. This is
Aschenbach in Britten's *Death in Venice.* The quick flit to the
wings for the quick change is the only time I leave the stage in
the entire opera.
Come the quick change I run into the wings where my two
dressers, a sweet and elderly couple, are hovering with a change
of shirt, tie, suit and shoes. There's no way we're going to
manage this. We're all tearing frantically at the three-piece suit
I'm wearing. They're yabbering to each other and to me in Italian.
I'm desperately trying to listen to the orchestra in anticipation of
my upcoming entry.
Cufflinks! Who on earth thought it a good idea to use cufflinks?

I hear what sounds like about five bars before I'm due to sing and I still haven't got my trousers on.

"Parto! Parto!" I squeak. I make my way towards the stage and the dressers are still tucking me in, trying to stuff shoes onto my feet. When I make my entrance I'm running on instinct. I've completely lost touch with the orchestra. I think I should start singing in about two beats but I'm really not sure anymore. I glance at the conductor but he's no use whatsoever. He's not having anything to do with the stage. He's leaving all that to the prompter. I'm so unused to the prompter concept that I tend to ignore him altogether. Too late, I'll just have to trust my instinct and come in.

I do, meanwhile trying to tie my tie and tuck in my shirt. My shoes aren't on at all. I'm scuffling along with my toes in alright but my heels haven't made it.

This is supposed to be a serene moment: Aschenbach wandering onto the beach and eulogising about the sun, the sea, the breeze... Why Aschenbach in this incarnation has decided to run onto the beach half-dressed is a twist in the plot that will have to remain unexplained.

I panic that I'm not singing in the right place at all and momentarily stop. Now I can see the prompter alright. He's manically waving his hands at me as if that alone will somehow make me sing. I can't make out what he's trying to do at all so I ignore him and listen to the orchestra, coming back in at the next spot I recognise. I've only omitted a couple of bars of melismatic eulogy and I don't think anyone will honestly notice (I mean, the howling mistakes I've heard in this piece during rehearsals... my error is small by comparison).

Another glance at the prompter and I can see he's slapping his head.

Bugger him, I'm back on the rails and he's frankly distracting.

Now, this is where I sit down in the canvas chair, no? Whoa, what's that?

There's a strawberry on the seat of my chair. If I don't remove it I'll end up with a mark on my white-trousered bum that will look like a bad case of piles. Strawberry removed as best I can, I sit down and finish putting on my shoes.

Only half way through the scene do I finally manage to be fully and properly dressed.

I shouldn't really be performing this at all. Yes, I was booked as an understudy but the guy I'm covering isn't ill. He's in the audience in fact. The story is so Italian. Just before the first night someone stole the laptop that has all the lighting cues saved on it and they had to postpone the show by a couple of days, pushing the premiere to the day before a schools matinee. Peter, the tenor I'm covering said he couldn't possibly sing two performances within 18 hours of each other so I was hauled into the boss's office. The boss is called Signor Vlad. He's a descendant of Vlad The Impaler. Seriously. That little fact doesn't help settle my nerves.

"We need you to sing second performance. Eees no problem?" he says with much the same tone he might ask for extra parmesan on his pasta.

"Well it is an enormous role and I won't have had any rehearsal but, no, it won't be a problem."

"Good."

And that's it.

I ring my agent and make sure he secures a vast fee, there being no mention in my contract of what would happen were I actually to go on because, frankly, they didn't look that far ahead.

I share a lift down to the stage before the show starts with a few of the chorus who are singing small roles and overhear them asking each other who the nut is who's stepping in to sing Aschenbach. When I tell them it's me, they look at me with expressions of wonder and pity that someone could be so foolhardy. They clearly think I'm *pazzo.*

Come the second half and I'm really enjoying myself. It must be something to do with knowing that this is my one shot at it. The expectations are low. The fact that I'm doing it all is something of a miracle.

As I climb the stairs to Aschenbach's hotel bedroom I can see ballet dancers tucked into loads of nooks and crannies, hidden from the audience, in anticipation of the upcoming so-called Wet Dream Ballet, where Aschenbach lies asleep while an orgiastic ballet takes place all around him.

Uh oh, another door handle.

I reach for it gingerly, praying it won't come off in my hand. I turn it and pull gently. Nothing. The door won't budge. I pull harder.

Still nothing. *Oh Christ, now what am I going to do?* I yank and yank, still nothing.

A dancer above me, who appears to be stuck into a recess in the ceiling, hisses:

"Spingere! Spingere!!!! PUSH!"

Ah, oh, yes, push. I push and the door opens, I climb onto the bed and the dancers stream in for their bacchanal. I should be lying there dreaming of Tadzio but I'm thinking: *well it's hardly my fault if I don't even get the chance to walk around the set.*

It's a schools matinee and most of the audience are here not because they are desperate to see a modern English opera about a German writer who develops a lust for a Polish boy but because they've been told they should go. They're a tough bunch as audiences go and who can blame them?

One thing is clear: they understand the title of the opera. They have also been lightly prepared for the plot. They know that at the very end of the opera Aschenbach dies.

I work this out when I collapse exhausted, as per the production, in the streets of Venice a good fifteen minutes before the end of the show. I'm not dead yet, I've got an aria and many more pages yet to do, but as soon as I hit the floor the kids in the audience obviously think: *that's it, the pervert has copped it, the opera is over, I'm outa here as soon as we've done clapping.* They burst into applause, cheering, whistling and yelling, and silence only descends again after a lot of shushing by their teachers.

Five minutes later I have to collapse again, this time in the hotel lobby. I'm reluctant to do it because I have a hunch what will happen. I try to collapse and give the impression of being very much alive. No use. Again the audience thinks *that's it, tea time,* and the yelling starts all over again. Again there's a lot of shushing and it slowly peters out.

When I finally die, in a deck chair on the beach, there's no shutting them up. They're screaming and stamping their feet even though the last page of music is some of Britten's sublimest. As far as they're concerned the credits are rolling and it's time to go. Tadzio's in the throes of his final dance but so what? It's nothing, the backdrop to a play-out, like the stuff that happens in the movies when they're reeling off the names of all the techies.

Through half-closed eyes I can see the conductor turning his head and telling them to shut up, but it's no use, nothing can be heard above the audience cacophony. He waves his arms, indicating to the orchestra to forget it and chucks down his baton. Rather than ending in a poignant silence it sounds like Christians-being-fed-to-the-Lions night at the Coliseum. Much as I'd like to pretend that this tumultuous reception is because I've knocked their socks off, I'm not quite that stupid or vain. Not quite. This is a collective yell or relief that they can get home to their Nintendos and Game Boys. My shuffling off of the mortal coil is their school bell. They're just doing what they imagine you should do when the fat lady finally, at last thank God, stops singing.

our play is preferred!

Aix-en-Provence, 1991

The audience is going nuts, and I mean *really* nuts. They're stamping their feet, cheering, the lot.

Wow, we certainly didn't expect this. We've been treated as the poor relation of the Festival, Plan B, something cobbled together when Plan A failed, left to rehearse in an old school gym on the outskirts of town.

And now this. All the pieces have miraculously fallen into place and we have a hit on our hands. Who'd have thought the French would go such a bundle on *A Midsummer Night's Dream* or *Le Songe d'Un Nuit d'Eté* as they call it?

The management of the festival, who until now have treated us with disdain, are suddenly smiling at us and issuing cheery *bonjours*. A revival next year is quickly planned. The show wins prizes.

We return to Aix the next summer and the head of the festival no less asks us, families et al, to spend a day at his villa, lunching and lounging at his pool.

A tour of France is planned, four months of performances in Paris, Lyon and beyond.

The production is bought by various other houses, some of which I can do and some which I can't. It comes to English National Opera. We take it to Ravenna. Last stop was Barcelona, almost 15 years since we first did it, but there is talk of further venues yet to come, just as long as I can keep convincing them I'm not too old.

It's good to have at least one gravy train in your singing lifetime and this is my Pullman.

Whereas actors rarely perform a role more than once in their life, singers frequently revisit a role in lots of different productions, but as often as not for only a handful of performances, and that after several weeks' rehearsal. To be like an actor, to play the same role in the same production over an extended length of time, with fewer weeks spent rehearsing than performing, is a rare luxury, and one to be truly relished.

most dear actors

Brighton Festival 1983

I'm booked to play Mozart in Rimsky-Korsakov's *Mozart and Salieri,* a setting of a short play by Pushkin which pre-dates Peter Schaffer's play *Amadeus* by about 150 years in speculating whether Salieri had a hand in bumping off Mozart. Schaffer's villain grinds Mozart down to death by subtle manipulation, but Pushkin is more brazen. It's a straight case of poisoning, m'lud.

Bernard Miles, *Lord* Miles no less and now in his mid 70s, has been booked to play Salieri in the play, with Graham Seed, aka Nigel Pargetter from *The Archers,* as Mozart. Peter Savidge is Salieri to my Mozart. The luvvies are going first with the Pushkin version, then there's an interval, then us.

Peter and I have been rehearsing for several days with the director Adrian Slack and the pianist David Owen Norris. We've staged it all - it's basically a mini opera and we're doing it properly. The hall is small and there's no orchestra to fight so we're aiming for a really subtle performance, as natural and understated as possible. It's a compelling little piece and we're rather pleased with the way it's shaping up.

The actors don't show up until the day itself. Unlike us, they're not going to be doing it from memory. They'll be in costume but they'll be carrying scripts. It's more of a "reading" for them. They rehearse on the same set as ours for an hour or so and when Miles is content and a little tired they stop.

The dressing rooms are make-shift. Bernard Miles has a small room to himself and the rest of us muck in together in another. We singers are never introduced to the grand old legend of the stage.

"Well I better go and wish the old man good luck" says Graham about ten minutes before curtain up, and he pops next door to the peer of the realm's room, leaving the door ajar. We can hear every word that is said.

"A word of advice," says Lord Miles in his best Long John Silver stage whisper, "those opera chappies will no doubt overact horribly. They all do. Keep it small, there's a good boy."

Ten minutes later Miles is out there laying on the ham in extra thick slices. His voice alternates between shouting and a

groaning whisper. He clutches the vial of poison aloft and stares at it with manic eyes. He flails around so much that he knocks over a couple of glasses. They're nice glasses too, the director's own crystal. Luckily they've already been used for the crucial poisoning or it's possible he might resort to strangling the rather bewildered-looking Mozart with his knuckley bare hands, accompanied for good measure by a manic cackle. Occasionally, in the pursuit of high drama, Miles gets lost and there are pregnant silences while Salieri scans his script to find his place again.

If Wolfgang Amadeus didn't think there was something decidedly fishy about Salieri's behaviour on the strength of this, he can't have been quite the genius he's generally cracked up to be.

let every man look o'er his part

Netherlands 2002

In the second week of *TEA* rehearsals, I have some concert engagements that are also in the Netherlands and for which I had been booked long before *Tea* landed in my lap. I'm going to sing Britten's *War Requiem* in Arnhem and Nijmegen, performances that are to remember in particular the victims of the terrible fighting on the Rhine in September 1944.

Every year a dwindling number of veterans of the battle come to Arnhem to remember their comrades, and some to pay homage, if that's not too strong, to the Ter Horst family. If you've ever seen the film *A Bridge Too Far* you may remember the scenes in which Lawrence Olivier and Liv Ullmann tend to hundreds of wounded soldiers in a devastated house, The Old Vicarage at Oosterbeek. That was the Ter Horst's. Kate Ter Horst nursed the wounded that inundated her home, while tending to her own five children, including a baby, hidden in the cellar. She tore up anything that she possessed if it would help dress a wound. She became known by British troops as The Angel of Arnhem.

One of Kate Ter Horst's daughters, Sophie, is to be at the concerts, as are many of her ex-patients and other veterans. Kate Ter Horst died after being struck by a car in 1992. With the image of the famous bridge in mind, Sophie has been instrumental in setting up the project *War Requiem – Bridge to the Future.* This has the simple but touching idea of using Britten's masterpiece to reconcile the past and to enlighten future generations. As Wilfred Owen, whose poems are interwoven by Britten into the requiem mass, wrote so famously "All the poet can do is warn". Sophie's project is true to that spirit.

The trouble is, the *War Requiem* is a demanding enough piece to sing without the added duress of rehearsing a new opera at the same time. I've sung the Britten many times so it's well under my belt, but I've never sung it *and* worked six hours a day on something else as well. Added to that, Arnhem is a good hour or so by train from Amsterdam. I'm going to have to prance around in pointy shoes all day, rush to catch a train, get to Arnhem in the nick of time for a full orchestral rehearsal, and then rush to catch a train back. With luck I'll be back at my apartment by midnight so that I can do the whole thing again on the next three days.

Despite an overwhelming sense of fatigue after a gruelling day, I am in Arnhem in good time for my rehearsal. I should be there a good half hour before it's due to start; time to get my bearings at the hall and nip somewhere for a quick bite to eat before work. Picking my way from the station to the hall I eye lots of tempting eateries, envying the people inside who are slipping merrily into an evening of convivial jollity while I have to go and put myself through three hours of angst and musical exploration. Don't get me wrong, I like rehearsals. I tend to prefer them to performances; I find the music-making more natural, more honest without the distraction of a paying public. And I love the *War Requiem*. But as there are times when you might choose to watch a Mel Brooks movie instead of putting yourself through the experience of seeing *Schindler's List* yet again, so it is with rehearsing the most moving of pieces of music. You know you should, but a chunk of you wishes you didn't have to.

As I get nearer to the hall I'm a bit surprised to see lots of musicians, recognisable because of their instrument cases, hurrying in the same direction. It's not generally my experience to see hardened musos rushing to get to work half an hour early, and I start to feel uneasy. I follow them into the hall, look around for someone in charge and when I find him, discover that my Dutch agent had screwed up and given me the wrong rehearsal time. We are due to start in five minutes.

The prospect of working for another three hours without food is too hideous. I find the conductor, whom luckily I know of old, and he lets me disappear for half an hour. I jog out of the concert hall, gulp down an enormous kebab in a near-deserted kebabatorium and jog back, my stomach rewarding me with spicy protests and a chorus of amusing gurgles.

I haven't missed much. In the *War Requiem* the tenor and baritone soloists sing almost exclusively with a chamber orchestra and it has been decided that we will rehearse on our own in another part of the building. I'm introduced to the young German baritone, Stephan, who looks as if he has just stepped out of an Armani shop.

I've yet to understand how this works. Most of the British singers I know, some of them enormously famous, dress similarly to me. Jeans or khakis, shirt, jumper. Standard casual dress. What most British males wear at the weekend. We're not clothes conscious as a rule. And what we are conscious of is the fact that there's no point wearing nice clothes if you're going to slide

around on a rehearsal floor in them. Most Europeans and Americans are pretty-well the same. Frankly most of us can't afford to spend much on clothes. So how is it that German singers, particularly the youngest who should by rights have no money at all, always dress as if they have just stepped off their yacht at Monte Carlo? How is it that all the long-established Brit singers I know drive around in modest second-hand family saloons when twenty-something baritones from Leipzig zoom around in flash Mercedes?

I suspect it may be to do with the fact that in Britain musicians are still treated as ne'er-do-well bohemians and in Germany they are revered as cultural heroes. Not that I'm envious or anything.

The rehearsal in Arnhem goes better than I could have hoped, considering how knackered I am and how much the hastily-swallowed kebab is making me burp and fart.

I let the German young 'un, whose first *War Requiem* this is, do all the talking. He seems to be of the type or generation that thinks that you can't interpret something unless you talk about it a great deal. This seems to me to waste a lot of time. Far better I think to connect with the conductor subliminally through your singing and find out what it is you both want to achieve. With a few exceptions, I don't particularly want to talk to a conductor and I certainly don't want him talking to me. Frankly, he shouldn't be encouraged to speak at all. Once he starts he may never shut up. Ask any orchestral musician and they'll tell you there's nothing more boring than a rehearsal in which you are constantly stopping to be talked at by a conductor. If the man, or woman, can't convey what he wants with his baton and his hands then he's in the wrong job. If a singer can only tell you what he's trying to convey by explaining it beforehand then he's also in the wrong job.

Come the Nijmegen performance and two thirds of the way through my big solo number, the tortured Agnus Dei, a huge fly buzzes around my head and then settles on my open score. Of all the 1400 people in the hall, why the hell does it have to choose me, the centre of attention? I assume that it will just fly away, but no, it sits there belligerently on the stave, blocking out chunks of notes in comic Tom and Jerry fashion until after I have finished. If it was aiming to be as big a nuisance as possible, it couldn't have timed it better. It lands just after I have turned the

page and there are no more page-turns until the end of the number. I can't exactly flick it away without utterly destroying the atmosphere I am working so hard to create. The thought passes through my mind - and I could well do without such distractions - that the fly is the reincarnation of Peter Pears and he is trying to balls it up for me. Not until I have worked my finest pianissimo on the final perilous phrase, held the audience with a poignant stare and whisked my score from the music stand does the mouche finally mosey off. It buzzes off into the orchestra and hangs out on a bow for a while. As the bow in question belongs to a viola-player this is a good choice by the fly. As any violinist will mischievously tell you, there's nowhere more static in an orchestra than a viola-player's bow.

clean linen

Belfast, 1997

"Right everyone, I want you to imagine yourself as a sack of corn, okay? Really relax now, okay? Now I want you to imagine that there's a small hole in the side of the sack and the corn is like ever so slowly spilling out, okay? Good. Slowly, slowly. Fantastic, that's really great. Let the corn slip out. Feel it go and slowly let the sack collapse. Good, lovely Carol, slowly Jeremy. Fantastic."

Oh god I'm too old for this stuff. But I play along because I'm just that childish that I still crave the approval of the director. Well, it's not even the director who's running the entire cast and chorus through this exercise but his assistant.

"Right down to the floor, that's right, lovely. And....... relax."

The opera is *Idomeneo* and I'm wishing so much that rather than lying crumpled on the floor like an empty sack - though I suspect mine actually looks a little full - I could be at home. My eight year-old, Adam, has broken his arm in the playground and is in hospital in Bath. And what am I doing? Can I be at his bedside? No, I have some urgent sack of corn impersonating to do.

After an afternoon of professional horseplay I walk back to my digs. It's drizzling, much as usual. The fee for this job is poor but they provide lodging, which saves a few bob. I have the use of a large but dreary house in a suburb, a mile or so from the church hall where we rehearse. The house is owned by a retired doctor who is away on holiday for a month. My only obligation is to feed a sulky cat called Mo. I'm not a cat person and this cat knows it. Still, he recognises that I'm the only one in the relationship who can manage the tin-opener so he does his best to keep on my good side.

This particular evening, I arrive at the house damp and dispirited, and there's Mo doing some of the things I don't like him for: walking on the kitchen counters, whinging to be fed, pretending he likes me because he hopes it might speed up the feeding process. I open a tin, plonk the contents in his bowl and then get on with my own stuff, first of which is to catch up on how Adam is doing. His arm is now in plaster and he'll be going home tomorrow.

Mo, meanwhile, has disappeared, I being of no more use to him. Fine. Suits me.

A few hours later I head up to my bedroom. It's the son of the family's room. He's now in his 30s I guess but the room is still decorated as if for a child. One wall is covered in Superman wallpaper.

What's that smell?

The windows are long painted shut. Every morning I wake up chilly but stuffy.

That smell is truly awful! What the hell is it?

I start to undress but the smell is so atrocious I really need to find out what is causing it. I shuffle around the corridors. No, the smell is definitely coming from my room. It seems to be worst near the bed. Hang on, why's my bed in such a mess? I lift the chocolate brown bedspread and reveal the problem.

As the perfect coda to my day, Mo the cat has made it clear he thinks as much of me as I do of him. He has crapped in my bed.

Flute's Fourth Scene: The Play Scene

The Rustics sing a nonsensical prologue to the Duke, his bride Hippolyta and the Lovers before Quince introduces the characters of the play. The play begins with Bottom and Wall. Flute enters as Thisbe and, overcome with nerves, he finds it hard to hit the right pitch. Eventually he gets it right and Pyramus and Thisbe duet, separated by the Wall. They exit and the Lion and the Moon introduce themselves. Thisbe re-enters for a tryst with Pyramus but is chased by the Lion. She drops her bloodied veil which is then discovered by Pyramus who believes Thisbe is dead. In his grief he kills himself. Thisbe re-enters, discovers Pyramus dead, sings a spoof Donizetti aria and then kills herself. Bottom offers an "epilogue or a burgermasque dance" and the Duke settles on the dance. The Rustics dance, midnight strikes and they leave.

if we offend

Brussels.

In my line of work you get to know a few composers. I was once having dinner with my favourite, Ollie Knussen, when someone asked him if he was going to write another opera.

"I would love to" Ollie replied. "The trouble is, I look at an awful lot of texts and think: *how on earth would this possibly be improved by me turning it into an opera?"*

Now you could argue that Virginia Woolf's *The Waves* could not be improved upon, but I would rush to disagree. I think it's a dreadful book and, more particularly, that it couldn't be much improved by turning it into an opera.

Still I don't hold myself up to be some sort of arbiter in these matters. If someone asks me to sing an opera based on Virginia Woolf, who am I to say that this will be a good or a bad thing? My job is to try to make it work, no matter how good or bad the material I have to work with. Most of us don't have the luxury of deciding whether or not a new piece is worth the paper it's written on before we agree to do it. We have to take it on trust that if, as in this case, Le Monnaie, Belgium's premier opera company, commissions a new opera based on Woolf's *The Waves,* it surely knows what it's doing.

Besides, I'll be singing a sizeable role, the only tenor role, so who am I to say "no, that doesn't sound like a good idea"?

It's not that the resulting opera is bad per se. There's some very lovely music indeed in it. It's just that the composer, a lovely guy called Klaas, isn't a man of the theatre. As if he can't believe his luck at winning such a big commission, not only has he indulged his passion for the queen of glum but he's gone all out and bunged in three "motets", in Portuguese, which we have to sing as well. They're very beautiful, dotted about in the middle of the opera, but have nothing at all to do with Woolf. It's almost as if Klaas feared this would be the only way they would ever be heard, and as he'd got the opportunity to do pretty-well what he liked, he might as well pop them in for good measure.

We premiere this piece, now called *A King Riding,* in the Circus Theatre, which was originally built as its name implies, to show circus acts. As I come on stage to start the opera I can make out that the house is about two thirds full, about 1200 punters. Not bad for a new opera by an unknown composer. I assume many

people are here as part of a subscription ticket. They've already paid; they may as well see what it is they paid for.

About half way through the first act the six singers have to go to the front row of the Circle and sing one of the Portuguese motets in an enormous fragmented ring. To get there we have to enter from the lobby behind the audience and on cue, walk through the audience to our preset positions.

I go to the lobby to my door only to find a constant stream of sour-faced Belgians coming out of the audience, putting on their coats and muttering to each other grumpily. I hear one mutter "quelle merde!" to another. I'm trying desperately to be invisible as I stand in my Edwardian suit and make-up, but I'm getting the odd resentful look as they swan past me, as if it's all my fault. They're coming out in such numbers that I have to shove my way through them to get to my place at the front of the Circle. "Excusez moi!" I hiss on my way through.

The place is emptying like an unblocked drain. When I get to my position all I can feel from the remnants of the audience that is left behind me is an unspoken "oh yeah, what now?"

By the end of the performance there must be only a couple of hundred left on their seats.

Perhaps I should blame the composer, perhaps I should blame our performance. Personally, I blame Virginia Woolf.

the true beginning of our end

It's ten-thirty at night, raining vigorously and we're driving north. I've just sung Britten's *Serenade* at a multi-purpose hall in a town somewhere in North Germany whose name I can't even remember. Albeit I'm working with a modestly-sized symphony orchestra, there were more people on stage than there were in the audience on this dreary January night. The orchestra is Danish, from Sonderborg, to where we're returning, the orchestra travelling on a coach.

In a car there's the Austrian conductor, the other soloist, a rotund and jolly horn player from Stockholm, the driver and me. It's a Mercedes I grant you, but a decidedly old one on which the windscreen wipers aren't working as well as they should. The driver is a little Dane of about seventy and I fear he can't see the road too well in this weather, let alone reach the pedals. As I watch the rain streak down the windows I form a question which I resolve to email straight away to all my friends and colleagues as soon as I get to my bleak hotel room back in Sonderborg:

"I don't stay in this business because I believe for a moment that it's going to get any better. I stay in it because every time I'm on the verge of giving up something comes along which is just well-paid and flattering enough to make me think I'll stick at it a little bit longer. *How much do you agree with this statement?*"

The replies come flooding back, some of them from highly respected names in the music biz: "TOO BLOODY RIGHT!" "STORY OF MY LIFE!" "TELL ME ABOUT IT!" "EXACTLY!!"

I've always maintained that the best moment of any job isn't the performance. It isn't the applause or even the fee.

The best moment of any job is the phone call when the offer comes in.

That's the moment when you know you are truly useful. It's also the moment when you can fantasise the most about what the job will be like, what an enormous success you'll be, how much you'll earn...

Everything afterwards is downhill. The realisation dawns how much you'll have to be away from home, how it will screw up birthdays and holidays. Then the excellent sounding fee doesn't sound so hot when you watch the rate of exchange drift against

116

you and there's an announcement of a tax hike in the country where you will do the job.

Then there's the nightmare of learning the role. For me this starts with a few trolls through the part at the piano. That's if the role has already been written and is in print. Quite often the thing is still a figment in the composer's head.

Singing it through at the piano is one thing. Memorising it is another. No matter how many times I sing something through with the score in front of me, none of it seems to get committed to memory. That's a whole new ballgame which usually starts with a session with a fluorescent highlighter and a ruler. It's something of a ritual. "Okay, this will really help get things going" I tell myself. I clear a table and go through the score highlighting my bits. It starts off as fun but after five pages or so it becomes a bore.

It's a mystery, but every time I finish highlighting a score I convince myself that I have taken a major step in memorising the damn thing, so much so that I'll often put the score aside and not open it again for several weeks.

As the job draws nearer, no matter how much I've told myself I'm going to get the role under my belt months beforehand, the score sits on the piano or in my briefcase raising a groan of guilt every time I clap eyes on it.

I must learn that bloody thing, I must learn that bloody thing.

The only way to do it is to set a timetable of utter boredom, of pacing around a room repeating it over and over again. Sometimes I'll take a walk and memorise at the same time. Train journeys are good if I can stop myself looking like a gibbering lunatic.

Inevitably there's a moment in the process when I think to myself "it's hopeless. I can't do this anymore. What happened? I used to be able to memorise stuff easily. I'm losing it." It seems that each new role is the hardest thing I've ever had to learn. Which leads to the question:

"Oh why did I ever say I'd do this bloody job in the first place?"

But this is usually the low point. This would be a bad time to start fixing digs and travel, to discover how much more of the once-tempting fee is going to disappear in expenses. Or to find out that so-and-so is also doing the show.... *he's a real pain in the arse, how on earth am I going to survive in such-and-such a city with him for two months for god's sake?!*

If I'm lucky I may finally have the role in my head about two days before I'm due to start the job. As often as not I'm in the same boat as most singers. I've learned, say, the first act but the other two acts are still a bit hazy. I *should* be able to keep ahead of the game and memorise them before we get around to rehearsing them.

And then the job starts and you're at the mercy of the director which, as I've already mentioned, is a whole new minefield.

So why become an opera singer? It's a question I've heard so many professionals struggle to answer. The singing is a given. We like to sing. No, we *love* to sing. We love to make music; we really, really do, when we can. And sometimes it's easy and it all comes together but a lot of the times it is really hard to make any magic happen at all. And there are the days when you have to sing when it's the very last thing on earth you want to do. That is, I suppose, what distinguishes the professional from the amateur. A lot of the time the professional simply has no choice. I sang a St Matthew Passion once when the bass singing Jesus had a raging cold, but being the consummate professional he brought it off very well. Someone from the choir said to him afterwards:

"Oh we had no idea you had a cold. We couldn't hear it." To which he replied:

"Good, thank you, but any fool can sing when they're in good voice."

And that's it. That's the task. To not let on. To make it sound as if you're always in good voice no matter how you really feel.

What else got me into this? Was it the sex?

In my early days sex seemed to be everywhere. I'll confess that I was actually a little frightened by the apparent aphrodisiac power that singing seemed to have. That sounds incredibly vain but, very early on, when I was singing romantic lead roles I kept finding myself in the situation where the girl I was playing opposite would want to take the role-play into the bedroom. That's all very well, but they were usually girls I had no interest in pursuing, either because I was already hopelessly in love with another girl or because I simply didn't fancy them.

Imagine being a 19 year-old student after an end-of-show party and having the professional soprano, who you know is married, pin you against a wall, stick her tongue in your teenage ear and suggest you both carry on where the opera left off....

(My response, which still makes me cringe today, was "oh, er, um, golly, I've got choir practice in eight hours, then Matins.... I really must get to bed or I'll be good for nothing!" It's not that she wasn't extremely attractive and sexy. I was just smitten with someone else altogether.)

And sometimes it would work the other way too. I would develop crushes on girls I was wooing onstage. All that soaring music, that breathy passion, that baring of the soul; it can wreak havoc with your emotions. It's very, very dangerous stuff we're dealing with here.

You have to make a decision either to run with it or deal with it. Some singers choose the former option and treat the jobs away from home as a licence to shag. Away from their families, bored and lonely, they seek some fun in the arms of a willing lover. I've done that, been there, won't do it again. It's simply not worth it in my book.

Besides, lest you've forgotten I'm the one who as often as not dresses up as the girl. Believe me, in my line of work, it's probably as safe a place from temptation as you can possibly be.

No, it probably wasn't the sex that got me on the opera stage. It just looked like a fun way to earn a living. And very often it can be.

The music's not bad either.

that you should here repent you

I never expected to feel so guilty. All the time.
That's the thing they never mention at music college, or anywhere in the training process, the guilt. Guilt not for performances bodged, though there's a fair bit of that, but for relationships strained, for children left at home, their bedtimes missed, school plays unattended and birthdays spent thousands of miles apart.

My first marriage doesn't survive the transition my career makes from domestic to international. I try to bring my wife and two young children with me whenever I can but when Tessa, my oldest, starts school, being away from home during term time is not an option anymore. I fly back and forth like a demon for weekends and between shows. It's exhausting, physically and emotionally.
After three years or so of spending several months each year away from home, the strain takes its toll. I have a ridiculous affair, my mid-life crisis, an eruption of my unhappiness. I'm singing *A Midsummer Night's Dream* again, in Holland, but this time I'm a lover, Lysander, which rather goes to prove my point before; it can be dangerous, singing a romantic lead. Julia, my wife, doesn't really blame me. She says she's surprised it wasn't her who went first.
After a terrible summer I move out and rent a friend's flat in Kilburn. Now I'm in digs and I'm only fifteen miles from home while I work at Covent Garden. The misery is truly overwhelming.
We try a reconciliation just before I set off on a four month tour singing Flute in France. The family joins me in Paris for half-term and it looks briefly as if we might succeed, but when the tour ends I'm off to Tel Aviv for two months, for *A Midsummer Night's Dream* again, and again I'm Lysander.
In Tel Aviv I meet Lucy who's understudying Hermia. She's from New York, dating a dentist. I talk about my marital problems. I talk even more about Tessa and Adam, now seven and five.
When I get home depression hits me again. It's a strange paradox that I now find myself in. I'm home, I should be happy. But being home means I am unemployed. I've earned well this year so money isn't a problem, yet. I'm just missing the work, singing, acting. I've got into this rut of pretending to hate being a

singer because I think pretending that will be good for my marriage.

And I realise I'm missing Lucy too.

We join another family for a holiday in Spain and I'm helpless with depression. I realise that it's not going to work. Julia didn't sign up to be married to someone who's always away and I didn't sign up to be married to someone who doesn't want me to sing abroad, who resents my career such as it is. We never saw this coming.

So why sing abroad? Simply because it's not possible to function as a solo singer anymore unless you do. You can't maintain a career these days in the home market. It simply isn't big enough. Something has to give and it's probably going to be our marriage. I end up sleeping in the attic.

Shortly after we return from holiday I'm off to Amsterdam again for three months. After that I have a two week tour of Japan followed by a week off at Christmas. Then I'm off to Italy and France for two months.

As I leave for Amsterdam I realise *that's it, I'm leaving my marriage too*. Within a couple of weeks we've agreed to divorce.

By now I'm writing to Lucy in New York every day, as she is to me. Julia has become close to a teacher she has met.

Almost a year later, Julia is moving with the children to Somerset to be with her teacher, and Lucy and I move to Wiltshire shortly afterwards, to be reasonably close to the children.

Tessa and Adam leave for Somerset at the end of a brief holiday with us. We rendezvous with Julia at a service station on the M3 and I hug and kiss the children goodbye. I'll see them in a fortnight. They drive off and we climb back into our car where I sob deliriously and convulsively.

My story is not unusual. The national divorce rate is about 2%. I thought it was higher but the internet says otherwise. Amongst my friends and acquaintances in the singing world I would say the rate is nearly 75%. It's an extraordinary statistic. If someone had told me when I was the spotty youth of 25 I don't suppose it would have made the slightest bit of difference. I would have said I'd be one of the other 25%.

my love thou art

There's something about opera fans that sets them apart from normal fans. I'm not talking here about people who simply enjoy opera. It's the fans, the people who cross continents to hear a certain singer. Continents? What am I saying? Many of them travel to the other side of the world just to hear opera.

When at home they listen to vast numbers of recordings, dissecting every phrase and breath of a singer's aria, pitting So-and-So's 1951 rendition of *Celeste Aida* against Bloggins' version in 1973 and declaring that while neither is perfect they still knock spots of *anything* that *anyone* can do today. No wonder we get nervous about opening our mouths lest it engender a collective sigh of disappointment from these people, our number one fans, without whose enthusiasm we couldn't carry on indulging in this most unusual of trades, people who are prepared to spend thousands of pounds to get to a performance that will almost certainly fill them with grief just so that they can say "I was there and OH MY *GOD,* it was simply a *disaster!"*

It's difficult to pinpoint what tips an opera lover over the edge into the realms of fan-dom. A larger than is healthy appetite for fantasy perhaps. Possibly a bit of suppressed blood-lust; there can be something rather gladiatorial about an opera performance after all - as many fans come to see singers whom they dislike fail as come to hear their favourites succeed. A quick scan through an opera internet chat room will reveal opinions on excellent singers couched in terms of truly elemental bitchiness. I grew up while Mick McManus, "The Man You Love To Hate", wrestled in black and white on the telly at teatime on Saturdays. I'm all too aware that, by accident, I've ended up in not such a different profession as the TV wrestler's. I just don't have to go five rounds with Giant Haystacks. Well, not quite.

In Tokyo, after the second performance of TEA a vast crowd of opera nerds comes scuttling around to the stage door. I've seen some fans in my time but this takes the biscuit. Tables and chairs are laid out so that we, the cast, can sign autographs in comfort for twenty minutes. A long queue of rather joyless-looking individuals waits to meet us. Each has an autograph book, a programme and several CDs, usually with little bookmarks showing where they want us to sign. They hand over the obscurest of CDs (and believe you me, most of my recorded

output could be described as obscure) which have barely made it to the shelves back home; how on earth these recordings have landed on the presumably enormous CD racks of this lot remains a mystery. How on earth do these people afford their expensive addiction?

As I sign their various booklets with carefully provided marker pens, out come their cameras and they grab a quick snap. There's a sad desperation about it all and the efficiency of the operation is a little eerie. The funny thing is, I get the impression that none of these people actually enjoys music or what it is we have just done; they are simply collectors. They gather us like butterflies and compete with each other for the rarest of the species. We're hardly the prize catches - Cabbage Whites I suspect, but they have to have us all the same.

Some hand over Japanese stamped addressed envelopes and ask us to send publicity photos. A fat lot of use the stamps are for posting anything from England and it's doubtful whether I'll get around to fulfilling such a business-like request when I get home. At least they've made the effort to provide some sort of postage. Perhaps after I've managed to catch up with paying the household bills and cleared the enormous and junky To-Do pile on my desk I'll think about it. Sending out publicity photos is not high on my list of priorities at the best of times. In fact I find requests for them pretty darn irritating. They don't print themselves you know! Some opera fans expect them as some sort of right and while most claim they are for personal use (and frankly I don't care to imagine what that use is), some have actually turned the acquiring of opera cast photos into a business. There's one particularly persistent Austrian who's always asking for them. Yes you know who you are! So stop it! Buy a programme, cut out the photo and stop pestering us! Go to the park! Take up stamp collecting instead!

I come without delay

Put me in charge of a conservatoire and I'd do some exercises with opera students to prepare them for the realities of the singer's dysfunctional lifestyle.

In a small room or corridor would be a number of deckchairs, each fitted with a seatbelt, set in close rows, and a fan heater. The students would have to sit in the deckchairs for ten hours overnight attempting sleep, with the fan blowing uncomfortably warm air at them. The lights would be turned on from time to time and the only way to the single lavatory would be to clamber over the other deckchairs.

After this experience each student would then be led into a concert hall and told to sing a particularly challenging aria. This whole experiment might give them some insight into the realities of the glamorous globetrotting lifestyle that awaits them, i.e. flying vast distances in economy class and then panicking when you feel in crap voice when you arrive.

The second exercise has each student living in a small, dingy room for two weeks. The room comes with a television and a telephone, but the television only broadcasts incomprehensible game shows in German and to call anyone else on the phone, no matter where they are in the world, costs a pound a minute. The only times the students can leave the room are to eat, for which they also have to pay a premium, and to work. "Work" consists, for the purposes of the experiment, of being in a dirty rehearsal room for six hours and being shouted at, again in German. If German is not available then any language other than English will do.

This experiment is to acquaint the students with the realities of the international career they so probably crave.

There's nothing new left to say about air travel that you haven't in all probability experienced yourself. But next time you are in Economy Class, or on a Ryanair bargain jaunt to a small airfield many miles from the city you thought you were travelling to, and you imagine that Business Class is full of company directors, film stars and opera singers, you'll probably be right but only on the first two counts. There almost certainly won't be any singers at the front of the plane. The guy in jeans across the aisle, on his own and looking more than a bit bored, refusing any alcohol lest

it dehydrate his vocal cords, could well be me, or any one of a ton of my friends and colleagues.

Travelling and Singing have become sullen bed-mates. It's rarely possible to finish one opera job cleanly before starting another. As often as not, the jobbing singer like me finds himself starting rehearsals for a new production in one city while finishing a string of performances in another. I don't have the clout to say "You just start without me and I'll join you after a couple of weeks when I'm done with my other job." I'd simply lose the job. And then where would I be? Out of work for a couple of months while some other eager beaver picks up the role that I need to pay the mortgage.

So I find myself, say, in the situation of performing in Madrid on Sunday, flying to London the next morning to rehearse all day for ENO before getting the last plane back to Madrid, performing again in Madrid on the Tuesday, doing another day return to London on the Wednesday and, again, singing in Madrid on the Thursday. At my expense I might add.

Other journeys are more complicated. One January I was in the south of France, singing a second-rate baroque opera in Montpellier, where I had been all alone since Boxing Day. After my last performance down there I had to catch four flights in one day to get me up to Sonderborg in Denmark to sing some concerts: Montpellier to Paris, Paris to London, London to Copenhagen, Copenhagen to Sonderborg. With a five hour stopover at Heathrow in prospect, Lucy booked a room at an airport hotel so that we could spend some time together for the first time in three weeks. She had something to do in London the next day so it was a perfect arrangement.

Perfect that is until it turned out that I'd eaten something duff some time before taking my first flight and I was rewarded with food poisoning whose chief symptom was spectacular diarrhoea. This gave new resonance to the term Frequent Flyer. Passengers on my first two flights gave me a wide berth, alarmed by my colour. Our romantic tryst at the Heathrow Sheraton took the form of me lying shivering in bed for a couple of hours while Lucy fed me paracetamol and mopped my brow.

By the time I stood in front of the Sonderjyllands Symfoniorkester (which roughly translates I'm told as the Danish Philharmonic, South Jutland Branch) to rehearse the next morning, I had eaten nothing for 36 hours but a Ryvita and several litres of water.

Occasionally, just occasionally, we singers do get the limo treatment. I did an arena *Carmen* in Dortmund with a canny promoter who persuaded a local Mercedes dealership to ferry his singers around by fibbing to the dealer that we were high-earners and therefore potential customers. Well, it may have been true of the Carmen and Don José but it certainly wasn't of the Dan Cairo and myself and I'm afraid it showed. No sooner were we inside these top-of-the-range motors than we were playing with all the switches and buttons like a couple of kids at the Science Museum.

No, I'm more used to public transport and no-one does it better than the Dutch. The pay-off though is that they are pretty crap when it comes to service. Not only that, they're rather proud of how bad they are at service. It's not that they are inefficient, but just a tad surly. Test your luck by asking at a KLM check-in for a free upgrade and the frost will descend faster than a prostitute's knickers on the OudeZijds Vooburgwal. "Why should I give you an upgrade? You have only paid for Economy. If you want to go Business Class then you have to pay for it, yes?"
If there's a Dutch characteristic that's not very endearing, for me it's their fondness for telling you bad news, especially if it's blindingly obvious, with more than just a hint of relish.
My family were with me once at Amsterdam's Amstel train station and we had fifteen minutes in which to buy tickets and catch a train east to visit the Kröller-Müller museum (which is a great summer's day out). There was a bit of a queue but not too bad. When my turn came I presented my German railcard for which I had paid the international RailPlus supplement, believing that this should get me discounts anywhere within Europe, but I wasn't sure. Mistake.
"Hello, I've got this card and I think it should give me a discount but I'm not sure," I said.
"Let me have a look. Yes I think this is all right. It says international."
She took my money, printed the tickets, and was about to hand me them when she had second thoughts. She asked a colleague who looked doubtful. Something along the lines of:
"Kan je Hollandse reisje gedoen met de reiskart op de Duitse Rail Plus?"
"Laatse me zeen." The first handed the card to the second.

"Verdomme. De man haste meer haar in de photo dan in de vles!! Ha ha ha!"

This was turning into a long conversation with just a tad too much laughter to make me comfortable. The clock was ticking and they were roundly ignoring my theatrical examinations of my watch while they handed the card around the office and chortled. Finally the girl said "No, my colleague says you cannot have the discount. That is only for travel between Germany and Holland. Not for travel just in Holland. For travel just in Holland you need the Dutch rail card not the German card."

I didn't want all this explanation. A simple no would have sufficed but needless to say I was given a fulsome one and it was too boring to relate here. We started all over again. By the time I was handing over more money I could see we had missed the train, so when I was finally handed the tickets I asked when the next train would be.

"You've just missed the best train!" the ticket girl said with an enormous grin.

"Now there isn't another for forty minutes, and it's a slow one which stops everywhere! You really should have got the last train, the one you just missed. That would have been a much better train to get. Now your journey will be really slow. Much slower than the train you just missed."

I wondered briefly if I wouldn't prefer to be back in England, listening to a computerised voice apologising for "any inconvenience" that my inevitably late train might be causing me. At least I'd catch the bloody thing, which is the only reason I can think that its tardiness could be not "inconvenient" in any shape or form.

It looked for a moment as if all of the ticket girl's colleagues were going to join in too, piling in with the bad news and the blindingly obvious:

"Have you noticed? You're going bald!"

"You have trodden in some dog shit. Now you will smell disgusting for the rest of the day!"

"Hey aren't you the guy who has to sing all those high notes? Those are really difficult. If you don't manage it, that will be really bad for your career, you will have no money and your children will starve!"

speak, speak, quite dumb

English National Opera had a resident bass, John, who though blessed with a beautiful voice didn't really have the temperament to make a long go of it as a singer. He was more famous amongst his colleagues for the amount of time he spent in the Coliseum canteen than for his stage appearances. John was a big man. Not only that, John was a very overweight man.

One night he was singing the role of the Water Gnome in *Rusalka*. In this particular production the Gnome was in a wheelchair, as Water Gnomes so often are, and all he had to do was to emerge through a trap door in the stage, sing for a page or so and then descend again. Easy.

John had a routine mapped out. He'd sit in the wheelchair on the lift under the stage awaiting his cue, which was a signal from the trap door operator, and on the signal he'd brace himself for the hasty ascent upwards to the stage, sing a few phrases, go back down again, spend some more time in the canteen, do the curtain call, go home, probably via the pub... bingo, the perfect night's work.

This particular night a pang of hunger had overcome John on his way to his preset position under the stage. The canteen being en route to the under-stage area he decided on a quick diversion. He bought a bowl of chips and took them with him to his wheelchair, where he sat loading them into his mouth.

Sadly for John that night, the trap door operator was a little distracted and when the time came for John's ascent he forgot to signal to John that he was about to throw the switch.

With a jolt the lift zoomed up. In a flash - as much as John could do anything in a flash - realising that even he didn't want to appear on stage at the Coliseum clutching a bowl of chips, he flung the half-finished bowl of chips to the trap door operator and continued his ascent.

Emerging onto the stage, John caught sight of the conductor in the pit who flicked him his cue.

Nothing.

John's mouth was still full of chips.

The orchestra played on. Still nothing.

As much as he could he tried to ingest them, but he'd taken a big mouthful and they just wouldn't go down. Or if they had left his mouth they were biding their sweet time in the descent of his throat. All he could do was sit there manically chewing in front of

the paying public while the orchestra murmured its lonely accompaniment.

When its cue came the lift descended again, not a note sung.

A few years after this story I'm in a converted barn near Hungerford. This barn hasn't been turned into a house. It has become a dinky theatre.

I'm playing - and never was the word "playing" better used by me - Vespone in Pergolesi's three-hander *La Serva Padrona*. The fee is absolute rubbish but I had an empty patch in my diary and I'm working with a couple of my best mates, the director Jamie Hayes and the baritone Richard Suart.

But there's something even better about the job.

Vespone is a servant who it totally and utterly mute. Not one note to sing. Zilch. Not only does this save me the tedious process of memorising the role, or even cracking open a score for that matter, I have absolutely no worries about the state of my voice, my health, watching the conductor, listening intently to the orchestra... in fact none of the disciplines I normally have to deal with.

The rehearsals only last five days from start to finish - it is a short piece I might add - and I see Richard and the soprano Sally struggle with remembering acres of tricky recitative. All I have to do is arse about for a living. This must be how Actors feel!

At one point Jamie wonders if it wouldn't be funny if I suddenly burst into song during the finale but I'm dead against it and dream up all kinds of bullshitty reasons why this would "spoil the integrity of my character". I just don't want to sing at all if I don't really have to.

At the curtain calls I get tumultuous applause for my antics and it makes me wonder if the normal addition of singing on top of my tomfoolery isn't an unwelcome distraction. How much better, for instance, would my Flute be received if I didn't actually make any sound?

Well I'll never know. I hope.

In the meantime I'm happy being a temporary Luvvy.

A bigger fee and it could almost be the perfect job.

thus Thisbe ends, adieu

Madrid

It's performance number five and we're upstage, behind the Umber Gnome's big idea, the milk-float truck, getting changed for the play scene.

For me this is pretty straightforward. Off with my overalls, down to my underwear, and on with the white dress. It's not a fancy white dress, just something long and white made out of sheeting. The usual sort of thing. Then there's the big blond wig. Easy. Finally I apply lipstick which I've secreted in the cab of the truck. I use the wing mirror to watch myself apply the lipstick and... voila.

Starveling's dog is particularly unruly tonight. Where did they get this dog? He's clearly not a stage dog, he's so poorly trained. He's always climbing our legs and yapping. Tonight he's very noisy. Well, the boys are deliberately getting him excited and making him bark, but even so, he seems unusually restless.

I go out and do my first bit, the singing out-of-tune gag, some business with the wall, then I'm back behind the truck.

Starveling is on his way out with the dog.

"Oh, watch out Chris, the dog peed." says Snug.

So he did. And how! I nearly stepped in it. There's a huge puddle behind the truck.

The sooner we get this over with the better. I've got to be up at 5 a.m. to catch the first flight to London. At this rate I won't be in bed before midnight and even then, will I manage to get to sleep? It's going to be a long day of rehearsals in London and then back to Madrid on the last flight.

"Oh my god, look!" hisses Snug.

While Starveling is singing his little aria, his dog is peeing right in the middle of the stage. Why didn't someone empty the dog before he came on stage?

Uh, oh, the dog is sniffing around and whinging in an ominous fashion. He's crouching, arching his back. Yes, the so-called stage dog is pooing on-stage in front of a couple of thousand horrified spectators. And the smell!

And now he's peeing again. Well this is just perfect.

By the time I'm out for my aria, my big ending, there are pools of pee everywhere. My usual route across the stage is hopeless. I'm having to tip-toe to get anywhere through the minefield.
But somehow that's not as bad as the smell. Every time I fill my lungs I'm treated to great wafts of it.
Well, here goes. On with the aria.

I bet Pavarotti never had to do this.

burgermasque

There's a hoary old singers' gag: whenever a phone rings during an opera rehearsal (particularly if this rehearsal is in some dump of a damp church hall and the session is unusually tedious) someone will loudly say "if that's La Scala, tell them I'm busy!"

Twenty-five years after I first sang the role at Covent Garden, and despite the fact that I am now fifty, the phone really has rung from Milan and I'm going to make my La Scala debut as - predictably enough - Flute.

By all accounts standards at La Scala are not what they were, and the newspapers are full of stories of strikes and disharmony. Despite a meaty signed contract I can't help wondering if it will even happen. Italian opera houses are notorious for cancelling productions at the last minute, and with the Italian government threatening to axe subsidies, every day I'm half expecting to get a call from my agent telling me the whole thing's off. A production I was asked to do in Bologna, but for which I was luckily unavailable, has recently gone down with all hands on deck. Let's face it, when it comes to putting bums on seats, a slightly obscure and, dare I say it, camp English opera wouldn't be the first choice of any Italian opera house struggling to survive. With a month to go before rehearsals, La Scala is talking of cancelling a run of *I Due Foscari* that is about to open, so I'm holding off buying my flight until the very last minute.

What is more, friends who have already sung at La Scala are full of stories of appalling organisation, disgruntled stagehands and lousy orchestral playing. And the streets are well-doused with dog poo. It sounds like the makings of a nightmare.

And yet it's La Scala.

That beautiful theatre! Eight weeks in Italy! The weather! The food! The fat fee! What's there not to get excited about? Besides, I'd like to meet the singer who doesn't want to sing at La Scala at least once in his career. Despite its reputation, to work there is still an enormous feather in any singer's cap. A singer who says otherwise is lying. Ask anyone, even someone without the faintest knowledge about opera, to name just one opera house and I bet they would manage "La Scala, Milan". It's like the Vatican. Even hardened atheists can't resist a look inside.

So, this will probably be my La Scala debut and, let's face it, my positively final farewell appearance there, all rolled into one. It will possibly be my farewell to Flute too. I mean, who in their right mind is going to ask an old git like me sing it in the future? That's difficult to say. There could be someone mad enough. I never expected to be singing it in my forties and here I am still at it. But when you get to fifty you have to accept that a lot of things you sing may be for the very last time. There's no escaping the fact that a lot of repertoire is a younger man's game and I'm getting used to saying goodbye to pieces of music I've been singing for years. Bye-bye *Cosi fan Tutte*. Bye-bye *Messiah*. Each year, the list grows.

But hang on. What if La Scala takes a shine to me? It could happen. It has happened before in other opera houses. Perhaps I'm predicting my demise prematurely. That voice inside Flute's head – which may as well be *my* head – still wonders whether *this* is the big break. Might there be some head honcho in Milan who sees me and thinks: *that man shouldn't be dressed up as a girl! He should be singing the male lead!! Quick, get him some trousers and hand me that huge bunch of contracts which I will offer him immediately!*

Well, I can dream Flute's dream.

What am I talking about? Isn't the fact that I'm singing at La Scala bloody Milan enough in itself? Doesn't it mean that this quest for whatever it is that drives Flute and me forward might be near its end?

And that quest is what exactly? To "*make it*"? Or to feel at least that I really have "*made it*". That sounds all very neat but is, of course, utterly ridiculous. There's no point in "*making it*" if no-one gives you any work and you can't pay the bills. Have Flute and I learned nothing in the last twenty-five years?

I've arranged some Milanese digs outside the city centre with a lovely landlady who doesn't want a deposit. Something of a miracle, that. I'm going to take it as a good omen. Bathed in optimism I might just go ahead and book my flight after all.

I've even taken the vocal score off the shelf for a quick revision.

Quince: *"Is all our company here?"*
Rustics: *"Aye...Aye..."*
Flute: *"**AYE!**"*

Made in the USA
Middletown, DE
30 November 2016